Harry Bertoia Sculpting Mid-Century Modern Life

Harry Bertoia

Sculpting Mid-Century Modern Life

Essays by

Jed Morse

Glenn Adamson

Sydney Skelton Simon

Marin R. Sullivan

Scheidegger & Spiess

Table of Contents

Foreword
and Acknowledgments

Jeremy Strick

Throughout the United States, the work of Harry Bertoia has been a familiar part of our lives for over seven decades, since his iconic Diamond Chair was first offered by Knoll in 1952. In fact, it was through the Knoll showroom in Dallas that Bertoia's sculpture entered the collection of Raymond and Patsy Nasher, as well as other prominent local collections. The artist's work soon extended to the public realm with major sculptures commissioned for new buildings (libraries, churches, office lobbies, public plazas) designed by some of the leading architects of the day, including Gordon Bunshaft, Eero Saarinen, and Edward Durell Stone. Yet it seems as if familiarity with his work has bred, if not contempt, then a false sense of security in our understanding. We think we know the work of Bertoia, but how well do we really understand its scope and reach?

Surprisingly, the last major exhibition of Bertoia's work in the United States was his first retrospective, a career survey of his sculpture and graphics mounted by the then-new Allentown Art Museum (which was close to Harry's home and studio in western Pennsylvania) in 1975, just three years before the artist succumbed to cancer. Now, more time has passed since that exhibition (47 years) than the artist was working professionally (about 36). While much important scholarship on Bertoia has emerged in the interim, the exhibition organized by the Nasher Sculpture Center represents a significantly rare occurrence. Not only is it the first retrospective of the artist's work in the United States in almost 50 years, but it is also the first survey of Bertoia's work that has attempted to bring together noteworthy examples from his multi-faceted practice encompassing jewelry, metalsmithing, furniture design, reams of unique works on paper known as monotypes, and thousands of singular, handmade sculptures including large-scale commissions and pioneering sounding sculptures. Drawn from public and private collections across the country, *Harry Bertoia: Sculpting Mid-Century Modern Life* offers an extraordinary opportunity to see the artist's full range of work gathered in one place and consider Bertoia's achievements anew.

Detail of *Untitled (Spill Cast),* 1960s

One contribution that comes to the fore is the example that Bertoia set in establishing a broad, interdisciplinary practice. Today, contemporary artists like Sterling Ruby, Tom Sachs, and Andrea Zittel move comfortably among a variety of media that bridge the traditional divides between fine art and craft, as well as apply themselves to projects with nominally more practical purposes such as fashion or furniture. The stigma associated with pursuing one's artistic ideas in the realms of functional design or in collaboration with more openly commercial interests appears to be fading. Artists now are free to practice in whatever circles are of interest and whenever opportunities arise. Bertoia's training at Cranbrook and his own comfortably interdisciplinary practice provide a vivid example for the current generation of an artist who pursued his esthetic and philosophical ideals across the vast spectrum of artistic production.

This publication makes a significant contribution to thinking on the artist. Jed Morse, Nasher Chief Curator and co-curator of the exhibition, served as the co-editor of this volume and contributed an essay that discusses the development of the artist and his work, interrogating the impact of Bertoia's interdisciplinary practice on the reception and understanding of his career. The project has been immeasurably enhanced by the guidance of co-curator and co-editor, Dr. Marin R. Sullivan, an independent art historian and curator based in Chicago, who also serves as the Director of the Harry Bertoia Catalogue Raisonné Project. Dr. Sullivan's expertise in the work of Bertoia steered the development of the exhibition and its catalogue, to which she contributed an important new essay on the artist's collaborations with architects as well as a survey of large-scale commissions in the Appendix. Dr. Glenn Adamson, a noted curator and scholar who works at the intersection of craft, design history, and contemporary art and currently serves as Senior Scholar at the Yale Center for British Art, has contributed an insightful essay that considers Bertoia's broad, interdisciplinary practice within larger contemporaneous trends in art. Finally, Dr. Sydney Skelton Simon, an art historian and curator specializing in post-World War II American art and design and the Bradley Assistant Curator of Academic Affairs at the Yale University Art Gallery in New Haven, offers new insights into Bertoia's lifelong work in monotypes and their relation to his broader practice.

As befits a genre-defying artist, *Harry Bertoia: Sculpting Mid-Century Modern Life* has benefited from the support of a diverse array of individuals and institutions. I would like to thank the National Endowment for the Arts for its early commitment to the exhibition, as well as the generous leading support of the Texas Commission on the Arts and Nancy A. Nasher and David J. Haemisegger. We are also grateful to the Dallas Tourism Public Improvement District (DTPID) and Humanities Texas for providing additional aid to the exhibition. Special thanks are due, as well,

to the Shifting Foundation for their generous backing of the concerts organized in homage to Bertoia and his sounding sculptures. Heartfelt thanks must also go to the museums, foundations, and individuals for so graciously entrusting the Nasher with works from their collections, especially the Harry Bertoia Foundation and its Director and Founder, Celia Bertoia, daughter of the artist, who has supported the exhibition from its inception through loans as well as her intimate knowledge of the artist, his life and work.

An exhibition such as this could not be achieved without the dedication and hard work of numerous individuals at the Nasher and beyond. Chief Curator Jed Morse led the effort of overseeing the exhibition, catalogue, and their many details, along with Dr. Sullivan. Working with Jed and Marin is the remarkable Nasher team: Head Registrar and Exhibition Manager Melisa Durkee, Associate Registrar Carra Henry, Conservator Claire Taggart, and Conservation Lab Technician Nicole Berastequi. Special thanks go to Curatorial Interns Austin Bailey, who secured many of the photographs and copyrights for this volume, and Giorgia Mastrolorenzo, whose dedication throughout the pandemic was essential to the related presentation of works from the Nasher Collection, *Foundations: Harry Bertoia*. Educational programs were developed for this exhibition by our Curator of Education Anna Smith, Manager of Tour Programs Lynda Wilbur, as well as Gallery Teachers Becky Daniels, Erin Frisch, Melissa Gonzalez, Paulina Lopez, and Sara Scherper. Marketing, publicity, and events were capably overseen by Director of External Affairs Jill Magnuson, working with Manager of Communications and International Programs Lucia Simek, Social Media and Public Relations Coordinator Katie Burton, Marketing Manager Chelsea Marshall, Senior Graphic Designer Lindsey Croley, Senior Manager of Emerging Technologies and Evaluation Jacques Haba, Manager of Strategic Events and Programming Lindsey James, External Affairs Coordinator Kirsten Macintosh, Manager of Visitor Experiences Isabel Lee-Rosson, and Assistant Manager of Visitor Experiences and Community Engagement Rachel Rushing. Fundraising efforts were overseen by Director of Advancement James Jillson, working with Director of Institutional Giving Vanessa Hadox, Director of Individual Giving David Leggett, Manager of Member Engagement Lauren James, Manager of Institutional Giving Cale Peterson, Manager of Advancement Operations Mari Ramirez, and Gift Processor Devin Berg. Chief Financial Officer John McBride and Senior Accountant Jennifer Lyons made certain that the project's financial needs ran smoothly. From my office, Executive Assistant and Patron Travel Coordinator Amy Henry worked with all members of our team, while Administrative Director Neil McGlennon and his facilities team—Facilities and Operations Manager Chris Bosco in particular—contributed their deep knowledge of our building to assure a smooth process for the installation.

Harry Bertoia: Sculpting Mid-Century Modern Life

Jed Morse

Italian-born, American artist Harry (Arri) Bertoia (1915–1978) occupies a unique position in the realm of modern art. He was one of the most prolific, innovative artists of the postwar period. Trained at the Cranbrook Academy of Art, where he met future colleagues and collaborators Charles and Ray Eames, Florence Knoll, and Eero Saarinen, he went on to make one-of-a kind jewelry, design iconic chairs, create thousands of unique works on paper and an equally staggering number and variety of sculptures, including large-scale commissions for significant buildings. Bertoia pioneered the use of sound as sculptural form and a diverse array of techniques, processes, and materials. His work speaks to the confluence of numerous fields of artistic endeavor but is united throughout by a sculptural approach to making and an experimental embrace of materials.

Bertoia had success in all of these areas. Museums such as the Wadsworth Atheneum and the Museum of Non-Objective Painting (which later became the Solomon R. Guggenheim Museum) purchased dozens of Bertoia's monotypes while he was still at Cranbrook. His jewelry, which he made primarily in the 1940s and only on rare occasions thereafter, sustained the young artist through the lean years during and immediately after art school and was highlighted in major design magazines and featured in important exhibitions, such as the Museum of Modern Art's *Modern Jewelry Design* in 1946. Although his time as a furniture designer was relatively short-lived—he worked at the Eames Office in California from 1944–46 and Knoll primarily from 1950–52—his accomplishments in this field are perhaps the most renowned, having won numerous design awards for chairs that have been in almost constant manufacture since 1952. Museums and private collectors enthusiastically acquired and exhibited his sculptures during his lifetime. And major architects such as Gordon Bunshaft, Edward Durell Stone, Saarinen, and Minoru Yamasaki regularly turned to Bertoia, among only a handful of sculptors that also included Alexander Calder and Henry Moore, for large-scale commissions for important buildings. It is

Detail of *Untitled,* c. 1958

Bertoia's success in such disparate arenas —from the intimate and personal space of jewelry to the domestic sphere of furniture, and the corporate, governmental, and public realms of commissions—that places him at the forefront of shaping the experience of life in the United States at mid-century.

Interdisciplinary cross-pollination distinguishes Bertoia's work, yet gaining distinction in so many different contexts may have, ironically, also contributed to his work being overlooked within today's dominant narratives of sculpture at mid-century. Although widely lauded and broadly collected during his lifetime, Bertoia's work largely fell from public view after his passing in 1978. This is partly due to the lifespan of large-scale commissions for commercial buildings: over the decades, as buildings changed owners and were repurposed or demolished, Bertoia's commissioned works were often sold or removed, excised from their original contexts or from view entirely. Some of the critical neglect is also likely due to a shift in the vector of art: as Minimalism and Conceptual Art took hold, interest in the older generation of modernist makers waned.[1] But perhaps another reason for Bertoia's work being overlooked since his passing is the interdisciplinary nature of his practice. Because he became so well known as the designer of the Diamond Chair, to the point of being featured in popular lifestyle magazines for it (fig. 1), it is possible that the rest of his output is seen through this lens: Harry Bertoia, the designer.

Bertoia's work was occasionally misunderstood during his lifetime. The commission for the Dallas Public Library provides a particularly illustrative case. Shortly after the debut of the Diamond Chair in 1952, and immediately on the heels of Bertoia's successful commissions with Saarinen at the General Motors Technical Center in Warren, Michigan and Bunshaft at the Manufacturers Trust Company Building in New York, the architect for the Dallas project, George Dahl, commissioned a sculpture from Bertoia for the city's new downtown library. The 10-by-24-foot multiplane construction was mounted prominently from the ceiling over the central circulation desk. Shortly after its installation and before the library opened, the mayor and City Council were invited to see the work. Much confusion and consternation ensued: the mayor said it looked like "a bunch of junk painted up." The Council members gave equally confused and disparaging assessments, and the group wondered if they had to accept it. Both local newspapers splashed the controversy across their front pages and added to the confusion by calling the work a mural, mainly because the official building specifications had called for one. Infuriated, Dahl offered to buy the work from the City and removed it for safekeeping. The hubbub surrounding the incident grew as the national wire services picked up the news. A group of concerned citizens who understood Bertoia's importance eventually resolved the situation, raising the money to reimburse the City for the cost of the sculpture if they returned it to its rightful place in the library. The work was back in place in time for the formal opening, and even the mayor eventually decided he liked the work, after being told it was not a mural but a metal screen: "That makes more sense," he said.[2] This episode reflects the difficult acceptance abstract art encountered (and still does) among general audiences, but also highlights one of the essential issues in Bertoia's work: its perceived relationship to function. Why is it that the work for the Dallas library, which the artist identified simply as a large, multiplane construction, "makes more sense" if called a screen? Bertoia's varied practice questions how and why we distinguish between a chair, a necklace, a screen, and a freestanding sculpture—and what his sculptural things, when taken together, say about the fluidity of visual language across culture, both at mid-century and now.

Bertoia's sculptural output reflected a moment when the possibilities wrought by scientific discoveries and technological innovation seemed endless and pervasive across

Fig. 1
Marvin Koner, photograph for July 1961 *Playboy* magazine feature, "Designs for Living."
From left to right are George Nelson on his serving cart; Edward Wormley and his "a" chair;
Eero Saarinen and his Womb Chair; Harry Bertoia and his Diamond Chair; Charles Eames
on his eponymous molded-plywood chair; and Jens Risom behind his open armchair.

all fields of intellectual and cultural inquiry. Artists, designers, and architects created a shared visual language in response to these advancements by exploring new, often industrial, materials and corporate collaborations at a time when they were not met with the same cynicism they so often are today. Writing in the pages of his influential magazine *Arts & Architecture* in 1950, editor John Entenza declared, "We have come into a time in history in which there is no longer any real separateness in man's activities and nothing remains to him that does not exist in close association with the whole of his life."[3] This sentiment of synthesis became a hallmark across vanguard sculpture, architecture, and design during the subsequent decade, in which Bertoia established himself as one of its leading practitioners.

Bertoia was part of this idealistic, interdisciplinary modernist endeavor from the beginning of his career. His time at Cranbrook proved formative. The Academy, established in 1932 as part of the Cranbrook Educational Community in Bloomfield Hills, Michigan, was modeled after avant-garde European academies such as the American Academy in Rome and the Bauhaus, which flourished in Germany between 1919 and 1933. The founding administration at Cranbrook, led by noted Finnish architect Eliel Saarinen, drew from a Bauhaus curriculum and ideology that sought to unify all the arts in service of the material world, ennobling the entirety of the built environment through the esthetic rigor and conceptual aspiration of art and design. Although emphasizing craft, the Bauhaus also recognized the potential of industrialization and mass production, adopting in 1923 the slogan "Art into Industry."[4] Like the Bauhaus, Cranbrook had no formal curriculum and encouraged broad creative exploration and collaboration. Eliel Saarinen described the school's philosophy as "a working place for creative art." He explained, "Creative art cannot be taught by others, each one has to be his own teacher. But [contact] with other artists and discussions with them provide sources for inspiration."[5]

The Academy admitted Bertoia in 1937 as a scholarship student to pursue painting and placed him in charge of the metal workshop because of his experience working with the material at Cass Technical High School in Detroit and the Art School of the Detroit Society of Arts and Crafts. His "painting" soon took the form of monotypes, unique handmade prints made as an escape from his duties when he officially became a metalsmithing instructor in 1939. As Sydney Skelton Simon notes in her essay on the monotypes in this book, Bertoia was essentially a self-taught image maker: "He worked alone in the printmaking studio at Cranbrook. No formal instruction was offered, and there was no community of printmakers—nor even any abstract painters—encouraging his efforts." The freedom at Cranbrook allowed for unfettered experimentation and led Bertoia to develop idiosyncratic variations of woodcut and glass plate printing processes. He also spent much of his time at Cranbrook in the architecture and design departments. He helped fellow instructors Eero Saarinen and Charles Eames with models and prototypes for their winning entry in the Museum of Modern Art's *Competition for Organic Design in Home Furnishing*. Eames later commented that the competition's aim, "and the aim of every competitor, was to provide the largest group of people with good furniture within their means."[6] Such an expression of egalitarian values typified the modernist vision proffered by the Bauhaus and continued at Cranbrook. The Academy sought to dismantle traditional hierarchies in the arts, while privileging experimentation and collaboration. This environment enabled Bertoia to envision art having a positive impact on every facet of life.

Bertoia's time at Cranbrook also provided one of the most enduring artistic provocations of his career. Many Bauhaus teachers emigrated to the United States as the Nazi regime rose to power and shuttered the school in 1933. László Moholy-Nagy, one

of its most prominent professors, moved to Chicago and established The New Bauhaus there in 1937. Bertoia's friend and Cranbrook colleague, Charles Eames, began teaching design at the Academy in 1939 and made frequent trips to Chicago to consult with Moholy-Nagy on pedagogy. In the early 1940s, Moholy-Nagy visited Cranbrook along with architect and Bauhaus founder Walter Gropius. The visit made a profound impact on Bertoia given that thirty years later, in 1972, he still remembered being seated at a luncheon across the table from Gropius, who "popped a very important question… 'What can you do with objects in space?' I didn't have an answer," Bertoia recalled, "and I probably am still working on it…"[7]

Bertoia's work in all media can be seen, through the lens of this encounter, as attempts to answer Gropius's provocative question. In a September 1952 article in *Architectural Forum*, Bertoia linked his artistic investigations in terms of explorations of objects in space: "In the sculpture, I am concerned primarily with space, form, and the characteristics of metal. In the chairs, many functional problems have been satisfied first … But when you get right down to it, the chairs are studies in space, form, and metal, too." Bertoia then links these with his early works on paper and his days at Cranbrook:

> *I used to make [monotypes] on the most transparent paper I could find—paint just a shape here, leave a lot of space around it, and then another shape and another color there. Then I would stretch the paper on a frame and hang it up against the light. The colors would float in the air, some closer, some farther back. I started to get interested in all of these space experiments long ago—at Cranbrook after I had been there a little while—and the floating-in-space idea is now in the chairs too.[8]*

Bertoia's comments highlight the essentially sculptural nature of his pursuits and unify a diverse range of work within the context of a Constructivist examination of the object in space. Herbert Matter's photographs of Bertoia's chairs for Knoll reflect this notion of the furniture being studies of forms floating in space (fig. 2). They also allude to their method of manufacture: tied together by thin wires, the curved steel grid of the chair was suspended in space from a single cable to be more easily rotated to weld the intersections of the bent steel rods.[9] The connection between the chairs and the sculpture was clear to Bertoia: they are both examples of what he could do with objects in space, and each has its own particular impact on our lived experience. Bertoia illuminated this view in a 1966 interview:

> *As a component of our environment, we cannot draw the line between a chair and let us say an object we see here (bronze sculpture). One stimulates the mind, the other comforts the body. The sculpture causes us to bring out a little more of our private being and the rapport is spontaneous. To sum it all up, it is a happier situation when the chair is just as good in its way as the sculpture may be good in its way.[10]*

Bertoia reflected a holistic view of the artist's role—everything, from a chair to a sculpture, was part of our environment and thus equally worthy of the artist's consideration. Bertoia did not deny the chair's relationship to its function, but its usefulness also did not diminish the object or its significance in his artistic pursuits or in our lives.

Abstraction, whether constructivist or organic in nature, offered Bertoia the greatest freedom to explore new expressive possibilities in the widest variety of applications; indeed, he adopted it as a core element of his own artistic language early in his ca-

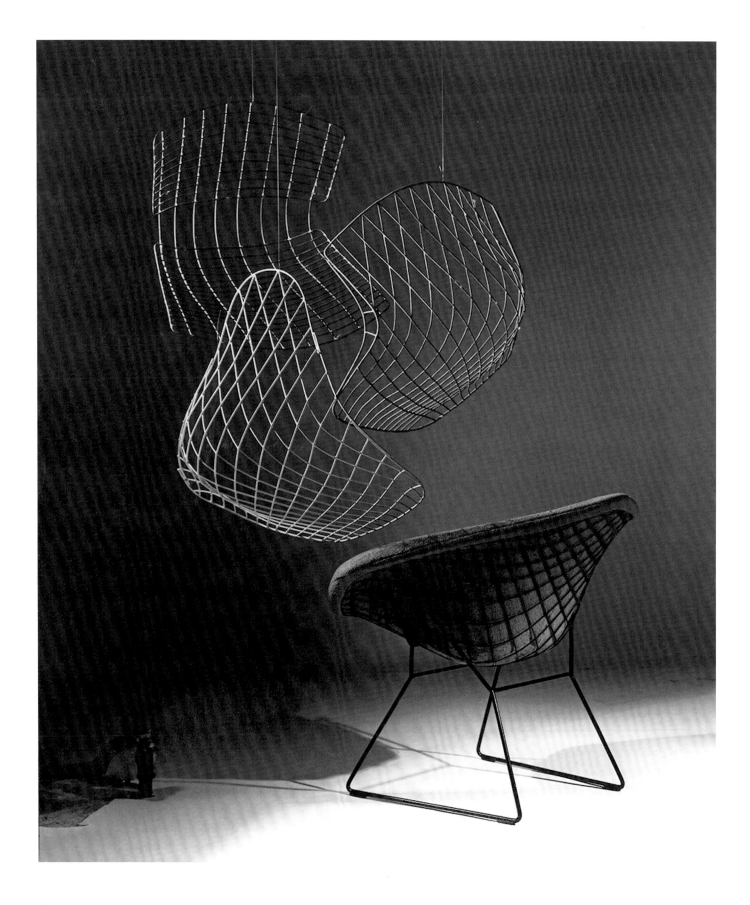

Fig. 2
Herbert Matter, photograph
of Bertoia's Diamond Chair

reer. The monotypes and jewelry he made at Cranbrook and later in the 1940s while living in California explored the expressive potential of both geometric and biomorphic artistic modes. Some early monotypes feature compositions of repeated geometric shapes stamped multiple times so that the application of ink diminishes with each stamping, creating a layered and atmospheric sense of space in the composition (cat. 11, 12, 14). Others feature curvaceous shapes swimming in swirling backgrounds or arrayed in a composition with registers reading as ground and sky (cat. 27, 28). Bertoia explored the possibilities of abstraction in his jewelry as well through exquisitely controlled geometric forms (cat. 6) or sinuous, multi-foliate creations (cat. 9). The space for these works, Bertoia understood, was that of the body, as in the brooches he made for Pipsan Saarinen Swanson's dress design (cat. 8), but they often suggested their own realms, whether the microcosm of insects and microscopic marine organisms or the macrocosm of the cosmos (cat. 4, 5, 7, 10, 24, 25). Even his metal works with more practical applications display the same consideration: a tea service, for example, made as a composition of layered elliptical shapes or a bronze vase segmented like the body of a centipede (cat. 1, 2).

Exploring the expressive possibilities of abstract, non-objective, constructivist art lends all of Bertoia's work an air of indeterminacy, which inevitably invites the question, "What is it?" Bertoia did not help the viewer much. He almost never titled his work (except on the rare occasions when pressured to do so by a museum or collector) and categorized various bodies of sculpture in terms of materials and processes: multiplane constructions, wire constructions, welded bronzes, spill casts, direct forgings, and sounding sculptures. Like many abstract artists, he preferred that viewers experience the work directly, without the suggestion of a title, and draw their own associations. This lack of identification or direction often led to the descriptive nicknames applied to his works by others. Thus, a multiplane construction, when used to divide or demarcate space, becomes more easily described as a "screen." Similarly, a wire or nail construction becomes a "cloud," "dandelion," "willow," or "sunburst." And a welded bronze composition becomes a "bush" or "tree." Bertoia welcomed these associations, particularly those with nature, which was a constant source of inspiration for him. Even the grid of the chairs, to him, was "a really organic principle, like a cellular structure."[11]

Bertoia did not want to reproduce nature's myriad forms but learn from its manifold ways of making, or, as he put it, to "parallel natural processes, rather than simulate the visible world."[12] Such an interest in how nature creates has roots in the modernist philosophy of Henri Bergson and his idea of élan vital, a vital energy that he posited as the source of all growth and creation in the universe. In an essay on Bertoia's jewelry, Shelley Selim traces his interest in so-called "neo-vitalism" to his Cranbrook years, particularly his introduction to William (Wilhelm) Valentiner, then director of the Detroit Institute of Arts and the father of a Cranbrook student, Brigitta Valentiner, who would later become Bertoia's wife. The elder Valentiner was a German émigré and a formidable art historian and curator, who had in his personal collection by the early 1940s works by significant European modernists such as Wassily Kandinsky, Ernst Ludwig Kirchner, Paul Klee, and Joan Miró, among many others. Exposure to these works and Valentiner's vast knowledge of Modernism provided Bertoia with some of the best examples of both geometric and organic abstraction. Moreover, Valentiner would have connected these works with Bergson's theories about a universal creative source. In a 1941 article on Kandinsky's painting in *Art Quarterly*, Valentiner states that his work is "not a mirror of life, but life itself" and that "thanks to [Kandinsky], painting has again been filled with [an] inherent and essential life force."[13] Other prominent modernists also professed an interest in creating

as nature does: Jean Arp wrote in 1920 that he wanted his art to be "a direct form of production … the way a stone breaks off from a mountain, a flower blossoms, or an animal perpetuates itself."[14] Then in 1946, in his book on modern sculpture, Valentiner lauded Bergson's significant impact on modern art, writing that, in "the most spiritual expressions of modern art … the theme is frequently the birth of life-giving forces, their transference to other parts of the cosmos, the constant change from one form into another, the connection between man and the cosmos in the same rhythm, the creative energy, or the cause of this rhythm."[15] As Selim concluded in her study of Bertoia's jewelry:

> His jewelry period was not a stepping stone to bigger concepts, but rather a den of experimentation from which an entire philosophy later evolved. It was an avenue for channeling the elusive, for convening and substantiating forms and feelings, and discovering his artistic voice. In tandem with his monotypes, Bertoia's wearable art embodies the quest to find and harness a vital energy that drives the whole of the natural world.[16]

Throughout his career, Bertoia sought to endow all of his work—whether a brooch, a chair, a monotype, or a sculpture—with the same conceptual aspirations.

Although rooted in experimentation and an intimate understanding of his materials, Bertoia consistently sought compositions that transcended their materiality and expressed something essential about life and the human experience. Ephemeral elements, such as light, often played an essential role in this transcendent experience of material. Bertoia made multiplane compositions to catch light from a variety of angles, most famously in the commission for the MIT (Kresge) Chapel at the Massachusetts

Institute of Technology (see p. 194), but also in more domestically scaled sculptures, such as *Construction after the Enjoyment of a Mulberry Tree* (cat. 44). In the multiplane sculptures, Bertoia emphasizes the materiality in the texture he adds to the plates through brazing. But this texture reflects the light in myriad ways. As Bertoia noted in 1955, "one prevailing characteristic of sculpture is the interplay of void and matter. … the reality of sculpture is to be found in the void, matter simply being an introductory device to the essential."[17] Suspending the grid of the chair to weld it may have suggested pursuing suspended sculptural compositions. Lightweight networks of welded wires and metal planes, these sculptures glimmer in the space overhead, changing as one perceives them from different angles, suggesting not only clouds (the term often appended to them) but also shifting flocks of birds, as well as constellations or even galaxies. Bertoia often brought his sculptures outside of his studio to photograph them in better light, and this gave him an opportunity to play with the works' potential connection to aspects of nature. A photograph of cat. 61 frames the sculpture against a glorious blue sky, the natural light illuminating the myriad of wires and planes making up its complex interior (fig. 3). An image of cat. 60 hoisted over a wire juxtaposes the form with a passing cloud (fig. 4). A group of black-and-white photographs of the same composition capture it over the pond behind his home (fig. 5). Here, the sculpture is reflected in the water, showing how the composition morphs and changes from different vantage points, but also simultaneously suggesting both a cloud, as it might be reflected on the water, and a school of fish, shimmering darkly just beneath the surface. Such associations with natural forms and phenomena evoke experiences common to many that nonetheless induce feelings of awe and wonder. That abstract compositions of metal squares and wires could evoke such powerful experiences outside of themselves is the manna of Abstract Expressionism and high-

Fig. 3
Photograph of untitled wire
construction (cat. 61), c. 1958

Fig. 4
Photograph of untitled wire
construction (cat. 60), c. 1957

Fig. 5
Photograph of untitled wire
construction (cat. 60), c. 1957

Fig. 6
Photograph of bronze spill cast panels for
Dulles International Airport commission
before installation, c. 1962

lights a transcendentalist streak running through Bertoia's work that harkens back to Bergson's philosophy and neo-vitalism.

Happenstance often led to innovation, but it was the serial, systematic pursuit of potential that resulted in soaring achievements. The spill casts of the 1960s emerged in this way. Touring the foundry at the Anaconda American Brass Company in Waterbury, Connecticut, a factory that made extruded copper and ingots, Bertoia witnessed tons of molten copper accidentally spilled on the floor. Refusing to be led away by his host, he watched in fascination as the material moved and pooled. This experience then came into sharp relief on a trip to Ossabaw Island, Georgia, where he reveled in the way that water and air currents shaped the land. Recognizing the artistic potential of harnessing the movements of molten metal, Bertoia began experimenting with it. Pouring molten bronze into sand beds outside his shop, he tossed bits of solid metal into the flow to alter its direction, manipulated it with rakes, and arrested the liquid in places cooling it quickly by dousing it with water. On other occasions, he used rocks, as in *Untitled*, c. 1966 (cat. 90), which sometimes resulted in explosions, leaving voids, as in *Untitled (Spill Cast)*, c. 1960 (cat. 88). Like Jackson Pollock developed an extensive vocabulary of paint splashes, drips, and splatters, Bertoia became an expert in harnessing the expressive effects of liquid metal.

His initial experiments resulted in the enormous spill cast bronze panels for the new Dulles Airport outside Washington, DC, designed by Eero Saarinen and Kevin Roche. Being a commission for an airport, he set out to make something that resonated with the experience, "leaving by plane or arriving by plane, having memories of looking down on the earth, or the expectation of going up and doing the same."[18] To ensure the panels cohered into a singular composition, Bertoia made the nine 8-by-4-foot panels (weighing four tons all together) in quick succession, a burst of almost non-stop work over two days. The massive sculptural field featured gnarled whorls and swirls of bronze, patinated in tones of green ranging from bright, lime green sprays to deep, oceanic jades and browns (fig. 6). The expansive wall installation recalled a vast landscape in microcosm, as if seen from an airplane. In classic modernist fashion, Bertoia's manipulation of molten metal was an index of its own making, plainly stating its formation and mirroring in its creation the elemental forces of volcanic activity and plate tectonics that shaped the earth from whence the material came. As Marin R. Sullivan notes in the appendix of Bertoia's large-scale commissions in this volume, even the Federal Aviation Agency, in its description of the work, invoked its ability to call to mind "the awareness of the relationship of man and space and the formative process occurring within our planet through time." The work came to be called *View of Earth from Space*—likely by its commissioners and viewers, rather than Bertoia himself. Placing the encounter with the work of art in terms of the grandiose forces of the universe and humankind's relatively miniscule place in it, no doubt would have pleased the artist, who certainly had such a transcendent experience in mind when he made it.

In this volume, Glenn Adamson argues that "Bertoia managed to bridge the art-historical space from Abstract Expressionism to Minimalism" in the serial, poured bronze panels for the Dulles commission. Yet, the development of the sounding sculptures may offer another example of Bertoia's work forging a crucial link between these two seminal, often opposed movements.

The sounding sculptures, which included tonals, gongs, and singing bars (cat. 95– 110), developed in the same analytical, serial experimentation with material as the spill casts (and, indeed, any of his other works, including monotypes, chairs, and other sculptures). Although he had been

working with metal rods and wires for years, Bertoia pinpointed the moment in which he realized the tonal potential of the metal he was working: "The very beginning was when placing a single wire on the backus for the purpose of bending it ... I heard a sound." The experience was not new for Bertoia, who had heard metal clanging on metal throughout his studio for years; but this was the moment when he grasped the potential of the aural element and thought, "what would two produce, or ten or a hundred."[19] Scholar Beverly Twitchell places that incipient event likely near the end of 1959.[20] What followed, after about a decade filled with other projects and commissions, were years of experimentation with wires, rods, and sheet metals in various materials, gauges, and quantities, examining the compositions for their formal visual qualities as well as their sonic potential. Of this close relationship between sound and vision, Twitchell recalls that "Bertoia always maintained that if a sounding piece looked right, it sounded right, and vice versa," offering the insight that Bertoia's "intuitive understanding is consistent with principles of physics, for acoustics and visual proportions are rooted in mathematical relationships."[21] Serial exploration resulted in serial production, particularly with the tonals: Bertoia expounded the basic template—orderly rows of metal rods, usually of the same length and thickness, arrayed evenly on a metal plate—into a variety of sizes and numbers producing a stunning range of sounds. The methodical analysis of finely milled proportions and the visual and emotional effects they produce could be a description as easily applied to Sol LeWitt's cube structures or Donald Judd's boxes as to Bertoia's sounding sculptures. Yet Bertoia's distilled, rationalized compositions produced the most intangible, ephemeral, and profoundly transcendent visual and aural effects when activated.

Music is the most abstract of arts, eliciting wellsprings of inchoate emotions, ideas, and even images simply from combinations of sounds, and the visual arts have often sought to slip their material bounds and aspired to the sublime state of music. In the second decade of the twentieth century, Italian Futurist painter Luigi Russolo promoted an Art of Noises, made experimental instruments, and performed "noise music concerts" that celebrated the cacophony of the urban industrial soundscape. With the sounding sculptures, Bertoia endowed the medium—long praised for its stability, permanence, and the mere suggestion of movement—with actual physical and aural dynamism. Set aquiver at the lightest touch of a hand or a breeze, the sculptures radiate the most extraordinary range of sounds, which listeners have variously likened to shimmering chimes and even whale calls, bellows from the center of the earth, the cosmic Music of the Spheres, and alien sounds from other realms.[22] Bertoia arranged sounding sculptures in his studio barn on his property in Barto, Pennsylvania (fig. 7) and would activate them for an audience of visitors, friends, and family in improvised concerts that reached the level of Gesamtkunstwerk, or total work of art, incorporating the presence of the sculptures glinting in the light, the balletic movement of the artist through the space, stroking, striking, and drumming on them, filling the barn with the sonic and sensory vibrations the sculptures emitted. At one point, he coined the phrase Sonambient to describe the experience and indicate the sensation of sound physically occupying space as sculptures and bodies do. Sonambient has persisted as a description of this total experience and Bertoia's endeavors in this field (and is often incorrectly applied to the individual sounding sculptures that create it). Bertoia used the term as the title for the collection of recordings that he made with his sounding sculptures in the barn between 1970 and 1975. These recordings, which he released on eleven LP records, were experimental and involved live performance layered with previous recordings simultaneously played back in the space.

22

Fig. 7
Sounding sculptures arranged in Bertoia's barn in Barto, PA.

The resulting sound compositions likewise carried titles that highlight the otherworldly, transcendent, and ethereal, such as *Space Adventure*, *Echoes of Other Times*, *Sounds Beyond*, *Vulcan's Play*, and *Ocean Mysteries*.

Typical for Bertoia, his achievements in sound are both revered by the few and overlooked by the many. The realm of avant-garde music holds these few recordings in high esteem for their contribution to the field, while collectors and curators often overlook the significance of the sounding sculptures for theirs. It should come as no surprise that Bertoia showed little concern about categorizing what he was doing. In 1972, Paul Cummings asked Bertoia if he thought of the sounding sculptures as sculptures, musical instruments, or something else. Echoing both Shakespeare and Aristotle, Bertoia responded, "Labeling it will not change its nature." He continued:

> *We can call it Joe and it's still the same shape. All right, so the label itself is of no importance and at one time I made an effort to come up with a collected name, a label that will refer to the whole thing and called it Sonambient, simply because it's sort of sound around. But it's rather clumsy and I'm not too fond of it. Now there are certain characteristics which almost call for attention. Number one, if a sculpture comes to mind and if we refer to sculpture of past ages we're quite certain that sculpture occupied a realm of science, it was the mystery of science that somehow evoked the quality that sculpture has, and in this case we have a complete reversal, we're giving a three-dimensional object which perhaps has no right to demand a place as sculpture but we cannot deny the fact that it is a three dimensional object, and it is*

not architecture. So by necessity we'll push it into the category of sculpture, but the fact is also that it has sound, and so for the first time then we are confronted with this puzzle of adding a sculptural element breaking silence, it has a voice, hence we listen to it, maybe there is something to say.[23]

Bertoia's response to the categorization of the sounding sculptures is characteristic of his attitude about making in general. If, since 1955, he sought to "parallel natural processes, rather than simulate the visible world," it is no wonder that he would allow those creations to simply be what they are, or as we say in contemporary discourse, to have agency, whether we choose to call it a brooch, a chair, a sculpture, or a musical instrument. What we call something is unimportant; what it tells us is everything.

1 This shift to conceptual concerns and the distancing of the artist from the making of the work of art prominent in minimalism was so powerful that by the end of the twentieth century young artists who began to take an interest in modernist makers like Calder and Bertoia felt prohibited from freely expressing it in graduate art schools, then largely populated with professors reared on Minimalism and Conceptual Art. These sentiments were expressed by artists on the *Alexander Calder and Contemporary Art* panel discussion, Nasher Sculpture Center, Dallas, TX, December 11, 2010.

2 The entertaining details of this episode in Dallas history are colorfully retold in A. C. Greene, "'A Bunch of Junk,'" *Texas Monthly* 14, no. 1 (January 1986), 124–28, https://www.texasmonthly.com/articles/a-bunch-of-junk-january-1986/.

3 John Entenza, "Notes in Passing," *Arts & Architecture* 67, no. 4 (April 1950): 19.

4 Alexandra Griffith Winton, "The Bauhaus, 1919–1933," in *Heilbrunn Timeline of Art History* (New York: The Metropolitan Museum of Art, 2000), http://www.metmuseum.org/toah/hd/bauh/hd_bauh.htm (August 2007, last revised October 2016).

5 Eliel Saarinen, "The Cranbrook Development," lecture given at the American Institute of Architects' Convention in San Antonio, TX, April 1931, 4, Cranbrook Foundation Records, box 26, folder 13, Cranbrook Archives, Bloomfield Hills, MI. Quoted in Shelley Selim, *Bent, Cast and Forged: The Jewelry of Harry Bertoia* (Bloomfield Hills, MI: Cranbrook Art Museum, 2015), 12–13.

6 Charles Eames, "Organic Design," *California Arts and Architecture* 58 (December 1941), 16.

7 Paul Cummings, oral history interview with Harry Bertoia, June 20, 1972, the Archives of American Art, Smithsonian Institution, Tape 2, Side 1; transcript, 7.

8 "Pure Design Research," *Architectural Forum* 97, no. 3 (September 1952), 145–46.

9 Celia Bertoia, *The Life and Work of Harry Bertoia: The Man, The Artist, The Visionary* (Atglen, PA: Scfhiffer Publishing, Ltd., 2015), 83.

10 Charles I. Kratz, Jr., "Harry Bertoia: An Interview," January 1966, manuscript, Harry Bertoia Foundation, 9.

11 "Pure Design Research," 145.

12 Harry Bertoia, "Light and Structure," speech delivered at the International Design Conference, Aspen, CO, June 1955. The Harry Bertoia Papers, General Business Correspondence (1946–1979), Notes and Sketches, microfilm reel 3850. Archives of American Art, Smithsonian Institution.

13 W. R. Valentiner, "Expressionism and Abstract Painting," *Art Quarterly* 4, no. 3 (Summer 1941): 234. Quoted in Selim, *Bent, Cast, and Forged*, 18.

14 Catherine Craft, "The Nature(s) of Arp," in *The Nature of Arp* (Dallas: Nasher Sculpture Center, 2018), 3.

15 W. R. Valentiner, *Origins of Modern Sculpture* (New York: Wittenborn & Co., 1946), 174. Quoted in Selim, *Bent, Cast, and Forged*, 18.

16 Selim, *Bent, Cast, and Forged*, 24.

17 Bertoia, "Light and Structure," June 1955.

18 Kratz, "Harry Bertoia: An Interview," 27.

19 Paul Cummings, oral history interview with Harry Bertoia, June 20, 1972, the Archives of American Art, Smithsonian Institution, Tape 2, Side 1; transcript, 24.

20 Beverly H. Twitchell, *Bertoia: The Metalworker* (London: Phaidon Press, Ltd., 2019), 224.

21 Ibid., 225.

22 See in particular the descriptions offered in the booklet that accompanies the *Sonambient* CD box set released by Important Records in 2016.

23 Paul Cummings, oral history interview with Harry Bertoia, June 20, 1972, the Archives of American Art, Smithsonian Institution, Tape 2, Side 1; transcript, 27–8.

Company Building in Manhattan (now known as 510 Fifth Avenue), this one 70 feet long (see pp. 50, 61). Any artist in New York City could easily have gone to see it for themselves.

No, the problem lies elsewhere, in what we might—prompted by Twitchell—call Bertoia's "maximalism."[4] Bertoia did *too much*. And he did so at every register of his practice. He made too much work in too many fields: he is thought to have completed several thousand sculptures, in addition to jewelry, furniture, prints, drawings, musical recordings, and other genres. Despite this volume, he also put too much of himself into these things. Unlike the Minimalists, who typically outsourced their production to fabricators, he created even his largest works by hand, in his own studio. He was a voracious experimentalist with formats and materials: though his practice did encompass ready-made industrial components like metal rods and plates, he also used more traditional art media, notably bronze. He also put too much into the work compositionally. While his works were serial and modular, they also featured departures from regular repetition. The panels of the General Motors screen, for example, are set at eccentric angles according to no particular rule and are punctuated with what might be termed sculptures-in-miniature. One could take the screen as a whole as merely the setting for these aesthetic incidents, like a backdrop for stage actors.

Above all, Bertoia sought to give too much pleasure. Early critical opponents of Minimalism, notably Michael Fried, characterized it as affectless and devoid of interest: "They had rid the work of so many formal decisions, so all that remained was an uninflected shape—a shape that declared its condition *as* shape," in James Meyer's words. "The literalist work aspired to the condition of a tautology."[5] Bertoia, by contrast, offered his viewers rich textures and burnished surfaces, the touch of the hand, and a degree of playful eccentricity—the sense of a sensibility. His New York dealer, George Staempfli, probably did the artist's reputation no favors

when he wrote that "Bertoia makes happy sculpture."[6] Yet he was on to something. Some critics enjoyed this aspect of his art: the great architectural critic Ada Louise Huxtable said of the Manufacturers Trust screen that it brought "a note of Byzantine splendor in an otherwise austerely elegant interior."[7] Others, however, took exception. Wayne Craven wrote that Bertoia's work "clearly belongs to the Constructivist movement, but turned to the use of the interior decorator." It was, he concluded, "sculpturesque"—and this was not intended as a compliment.[8] In 1961, a reviewer in *Art News* had this to say: "Harry Bertoia's metal sculpture projects a sense of installed decoration; as such it represents a kind of contemporary Victorianism for an over-industrialized bourgeoisie, steel and bronze counterparts of the aspidistra and the potted palm … It is always some kind of delight to see a perfect manifestation, perfectly related; in this case we have the aesthetic of a realm whose perfect expression is *Fortune* magazine."[9]

It was all too much: too shiny, too splendid, too ingratiating. Bertoia's placement of his work in public venues also meant that his sculptures were literally treated as decorative art. (The General Motors screen divided a lobby from a cafeteria, and diners often hung their jackets on it; he is supposed to have commented, "This is all right, but does not help the design."[10]) In his tendency to accept such conditions and to aesthetically over-deliver, Bertoia can be compared to certain architects active at the time such as Edward Durell Stone, Philip Johnson, Morris Lapidus, and Eero Saarinen himself (fig. 2). As Alice T. Friedman wrote, all these figures sought to moderate Modernism through glamour—an effect they typically achieved through ornamented surfaces and luxurious materials. Their motivations were complicated; in part, they wanted to soften and sweeten the Modernist idiom to help it succeed by increasing its public appeal. Yet they were by no means populists. "Glamour is a specialized language," Friedman noted. "It is a multilay-

Bertoia's Maximalism

Glenn Adamson

"Once, sitting in the barn talking, with all those pieces standing still and silent, I asked if he thought his work was related to Minimalism. He laughed, walked over and gently prodded a tonal piece. Saying essentially: *Isn't this maximal?*"[1] This is a story from Beverly Twitchell, who occupies a unique position in Harry Bertoia's life and legacy. Curator of two groundbreaking exhibitions on the artist in the 1970s, she recently published a developmental study of his work.[2] So while this little anecdote may appear offhand, just a slight exchange, it seems worth taking seriously. All the more so as it is one of few indications we have concerning Bertoia's relationship with Minimalism—a movement that he might today be considered to have inaugurated, had the arc of art history bent in a slightly different way.

Consider Bertoia's sculptural screen for the General Motors Technical Center in Warren, Michigan, commissioned by Eero Saarinen, a friend from his days at the Cranbrook Academy of Art **(see pp. 52, 56)**. Stretching a heroic 36 feet in length and standing 10 feet high, this monumental composition completed in 1953 was his first large-scale multiplane construction. It exemplifies Bertoia's interest in the "interplay of void and matter, the void being of equal value to the component material units."[3] It requires no great imaginative leap to see it as a precedent for Minimalist work made a full decade later. It's all there: the constructivist vocabulary, the modular seriality, the ambitious scale, the obdurate materiality. Put it next to a wall piece by Donald Judd (if you can find a wall large enough to hold them both) and the similarities will be undeniable **(fig. 1)**.

Yet this is a false correlate—bad art history, at least by prevailing standards. For several generations, the interpreters of Minimalism, beginning with Judd himself, have studiously ignored Bertoia. It's not so much that his position as a crucial forerunner of the movement has been rejected; more that it has never been considered in the first place. Why is this? After all, he was hugely prominent in the late 1950s. He himself may have been sequestered in rural Pennsylvania, but his work was abundantly published and exhibited. The year after the General Motors commission, Bertoia installed another, similar screen in the Manufacturers Trust

Detail of *Untitled (Cube)*, c. 1968

Fig. 1
Donald Judd, *To Susan Buckwalter*, 1964,
galvanized iron and blue lacquer on aluminum,
30 × 141 × 30 in. (76.2 × 358.1 × 76.2 cm),
Judd Foundation

Fig. 2
Edward Durell Stone, Stuart Pharmaceutical Company,
Pasadena, 1958

Fig. 3
Sol LeWitt, *Wall Drawing #370*, 1982. Installation view,
The Metropolitan Museum of Art, New York.
Courtesy of The Estate of Sol LeWitt

ered representation constructed by experts, and it is aimed at people 'in the know.'"[11]

This sort of elitist refinement, which one could attribute to Bertoia's work as easily as to the buildings it sometimes inhabited, was exactly what the Minimalists wanted to reject. Through extreme restraint, they hoped to arrive at an art of integrity, logic, and resolution. Of particular importance was the concept of *Gestalt*, meaning a whole shape without internal part-by-part divisions. In his essay "Specific Objects" (1965), Donald Judd famously asserted, "Most works finally have one quality," and then went on to explain: "It isn't necessary for a work to have a lot of things to look at, to compare, to analyze one by one, to contemplate. The thing as a whole, its quality as a whole, is what is interesting."[12] The sculptor Robert Morris, during his Minimalist period in the early 1960s, was even more particular in enumerating characteristics to be avoided. His not-to-do list included "the highly decorative, the precious, or the gigantic. There is nothing inherently wrong with these qualities; each offers a concrete experience. But they happen not to be relevant for sculpture."[13] Also, "such things as process showing through traces of the artist's hand have obviously been done away with." And "the sensuous object, resplendent with compressed internal relations, has had to be rejected."[14]

Thus, while the unprejudiced eye might see strong parallels between Bertoia's work and that of the succeeding generation, he found no place in their personal pantheon. And that, for about fifty years now, has been that. But what if we were to revisit this little patch of art history, with its strict territorial demarcations, and take a more expansive view? If we were to step outside the prescriptions of Judd and Morris? If we were to notice that Bertoia's work not only looks like theirs in certain key respects (and was made up to a full decade earlier) but, more importantly, is productively juxtaposed with orthodox Minimalism? This shift in perspective is consistent with recent scholarship, which

has sought to broaden our understanding of postwar abstraction in several dimensions simultaneously—geography, biography, and genre. As Anna Chave has argued, "There have been all along not one but multiple Minimalisms."[15]

We might extend this thought further and ask not only whether there were strong affinities between Bertoia's maximalism and the work of the succeeding generation, but also whether he might not have offered something they missed, which looks in retrospect to have been just as generative as their acts of refusal. This requires a certain amount of extraction from the work itself, for Bertoia did very little writing about his own work. In an oft-quoted letter, he said that he "did not start with a written credo or manifesto... School days exposed me to the hows more than to the whys or the whats."[16] At a moment when manifestos played a decisive role in shaping art discourse, to the extent that the art itself could seem merely illustrative of ideas, he preferred to spend his time—almost all of his time—in the studio. He lived the ethic, and the daily rhythms, of a craftsman.

This artisanal methodology helps to explain Bertoia's particular approach to seriality, which in some respects anticipated Minimalist practice and in others was its very antithesis. It has been truly said, again by James Meyer, that "a work looked *more* like a Judd when it was not *made* by Judd—when it was built by someone with superior technique."[17] This was equally true in the case of other artists associated with Minimalism. For example, Carl Andre primarily employed existing industrial units; Tony Smith, Barnett Newman, and others collaborated with Lippincott, Inc., the first American company to specialize in art fabrication; and of course Sol LeWitt explicitly conceived his work as sets of instructions to be executed by others (**fig. 3**). In general, sculpture in the 1960s was increasingly dependent on a division of labor between artists and fabricators: a trend that has continued and accelerated to today.[18]

Bertoia, who developed his mature work before such external resources existed, designed his sculptures so that every element of them could be managed by hand. This, as much as any allegiance to Constructivism, is why his large-scale installations were composed of numerous related units. How else would he have traversed all that square footage while working at the scale of a private studio? He approached the making of the General Motors screen, and related work, rather as one might tile a wall; and the subtle variation of the panels lends the overall work life, a certain variety and vitality, just as ceramics often do in architecture. Indeed, the roots of this approach are to be found in Bertoia's experience of applied arts. The constructive logic of his screens is a giant-sized implementation of structures he often used in making jewelry at Cranbrook: substantial elements mounted on light armatures.

There is also a strong connection here to Bertoia's iconic Diamond Chair for Knoll. It is composed of numerous pieces of standard wire, each one cut to a slightly different length and bent into a slightly different curve (see cat. 36–38). Together, the bits of metal describe a single compound shape, but each was manipulated with a simple hand jig, then cut on the end at an angle, soldered, welded, and buffed. It is worth noting that Knoll, at the time that Bertoia began there, was hardly a massive industrial operation. When he arrived in Pennsylvania, he first set up in a woodshop, without metalworking tools of any kind. Even when the diamond chair was far along in its development, Bertoia (together with designer Richard Schultz and technicians Don Pettit and Bob Savage) continued to work in a small atelier, not too different from his own sculpture studio. Thanks to this hand assembly, each chair is subtly unique. What is more, it is premised on a particular serial logic, whereby each unit is incrementally differential.

This was the core of Bertoia's method, whatever he was making. He thought in terms of theme and variation: every line, every shape, every form a development of the previous one, never an exact repetition. He often spoke of this rippling, fugue-like structure in organic terms: "It is pleasurable to do smaller works and the kind that fills other needs, the main objective being to give form for possible growth, as well as the delight of immersion."[19] His dandelion and bush sculptures literalize this idea—they actually look like plants (see cat. 69, 81). Indeed, these bodies of work (like everything else he made) were derived through workshop experimentation. Bertoia was imitating the underlying developmental logic of nature, not simply imitating its forms. In this respect, he can be compared to others involved with "organic design" at midcentury, who were similarly inspired by the integral logic of natural forms, and also to more recent designers who have employed the language of algorithmic calculation in a way that reprises biological growth processes in the digital context[20] (fig. 4).

Bertoia's use of constant inflection also recalls the traditional modus operandi of handcraft. Artisans typically create extended runs of objects, each one slightly different from the next. Over time, and as skill increases, the results tend to migrate away from the original model. Twitchell, who observed the artist working in his studio, commented that his tendency to work in series evolved from this "constant intellectual probing of what he was doing, problem-solving … a consideration of possible alternatives combined with his love of process." In the 1950s, this approach had a particular resonance, for the decade marked the apex of the so-called Designer Craftsman movement. The idea was that makers could remain rooted in hand production but contribute to industrial manufacture, and in this way humanize and improve mass production.[21] Unfortunately, American industry proved difficult to convince, and it remained more of an ideal than a general practice. There were exceptions, though, and Bertoia would have known them well. At Cranbrook, weavers like Loja Saarinen, Marianne Strengell, and Jack Lenor Larsen had

Fig. 4
Joris Laarman, *Bone Chair*, 2006, aluminum,
29 1/2 × 17 1/2 × 30 in. (75 × 44 × 76 cm),
Courtesy of Friedman Benda

Fig. 5
Richard Stankiewicz, *Untitled XXXII*, 1960,
welded metal, 37 × 35 × 30 in. (94 × 88.9 × 76.2 cm),
Raymond and Patsy Nasher Collection,
Nasher Sculpture Center, Dallas

created handloom samples that were used as the basis for machine-woven fabrics. In California, Edith Heath and other manufacturers adopted the same strategy in producing prototypes for their ceramic tablewares. And Charles Eames, with whom Bertoia collaborated in the late 1940s, strongly aligned himself with this perspective: "The responsibility for a decision—aesthetic, practical and connected with craft—has to be set back in the industry itself ... Mutual understanding will do much for both."[22] Bertoia's work for Knoll can be seen as exemplifying this Designer Craftsman philosophy.

A final point about Bertoia's approach to seriality has to do with the question of self-expression. He has been compared to other sculptors of his generation who employed welding, such as David Hare, Reuben Nakian, Herbert Ferber, Seymour Lipton, Richard Stankiewicz, and even John Chamberlain, on the grounds that all "scorned the old notion of sculpture as solid mass, and began opening up space within their forms and animating the surrounding space as well"[23] (fig. 5). The implication here is that welded metal could be used, just like flung paint, to destroy conventional formal structure. But Bertoia's craft-based seriality made him quite unlike the other welder-sculptors of his generation. Excellent workmanship, of the kind he practiced, has a way of simultaneously effacing and declaring itself. The marks of his making are never overstated. Points of intersection are beautifully modulated, and surfaces and textures lovingly coaxed into being. To quote Twitchell again, "So precise is his geometry, so perfect his welding, and so articulate his logic that instead of calling attention to the artist as an extraordinary individual (virtuosity at its egotistical worst) Bertoia's immaculate technique transcends the personal."[24] This seems right, yet there is also a powerful undertow of individual assertion in the care he brought to his work. Look for a single vigorous gesture in his sculptures, and you will not find it, yet the force of their accumulated material intelligence is palpable.

In this way, without indulging in the macho egomania that both idioms tended to foster, Bertoia managed to bridge the art-historical space from Abstract Expressionism to Minimalism.[25] No work of his exemplifies this better than the untitled work popularly known as *View of Earth from Space*, a nine-panel wall sculpture he installed at Dulles Airport, near Washington, D.C., in 1963[26] (fig. 6). An utterly fascinating project, it has had relatively little scholarly attention and is admittedly idiosyncratic even within Bertoia's diverse oeuvre. Nominally, the panels fit into a genre of his work known as "spill castings," which he made by freely pouring molten metal into beds of sand. This resulted in objects resembling coral or geological specimens—again, Bertoia's interest in reproducing the dynamics of nature is evident. The Dulles panels are different from the other spill castings, though, in two key respects: first, they are much larger in scale; second, they are rectilinear and serial in format. Together these qualities, as well as the work's brutal facticity, do position the wall sculpture in proximity to Minimalism. Yet not that close: there is a thematic and material richness here that is entirely his own.

Eero Saarinen first proposed Bertoia for the Dulles commission, but he did not live to see it—he passed away in 1961 and the airport was completed by architect Kevin Roche. The aeronautical setting inspired Bertoia to think about terrain seen from above; it seemed to him that he had been challenged to invent an iconography of "the Air Age."[27] As he was considering this, he had two adventitious encounters outside his studio. The first was at the foundry of the Anaconda American Brass Company in Waterbury, Connecticut. While touring the facility, a large furnace accidentally spilled to the factory floor. His guide, embarrassed, tried to steer him away, but Bertoia insisted on watching as the metal cooled, transfixed by the lava-like motion. The second was on the shoreline of Ossabaw Island, off the coast of Georgia. Bertoia recalled: "The feeling of change caused by one

Fig. 6
Harry Bertoia, *Untitled* (also known as
View of Earth from Space), 1962,
spill cast bronze, 8 × 36 × 4 ft.,
Dulles International Airport

element eroding and shifting and another equally powerful force causing the trees to grow, came to bear on my other impression of the spilled bronze, and the two images fused and led me to think that metal used in its liquid state could in some way express at least part of the perpetual upheaval."[28]

This origin story, with its overlay of the industrial and the natural, is fully realized in the Dulles panels. Far too large to make in his workshop, they were poured at the Guittner Foundry in nearby Reading, Pennsylvania—a rare venture for Bertoia into the domain of external fabrication. He remained hands-on as much as possible, however. After the bronze was poured into prepared sand beds, the artist employed various long-handled tools to manipulate its molten surface. It was, he said, "like being face to face with the sun."[29] Originally, he hoped to execute all nine panels in one day, fearing that changes in atmospheric conditions would result in noticeable differences. This proved true: the team was unable to finish the work in a single day shift, and two panels cast the

following morning do have a slightly different appearance. Following the casting, he further worked on the surface, adding texture and patination. But for the most part, after long weeks of preparation, it was a matter of nearly instantaneous execution. As Bertoia put it, "The process allows for no second chance. No re-doing, no re-touching, except for coloration, no re-forming— it's a one-plunge deal." He emphasized parallels with Jackson Pollock's dripped and poured paintings, which were similarly rapid in execution and similarly transformed the landscape genre into sublime abstraction. He noted, however (with a hint of pride), that Pollock "had a cool medium and could rest if he wanted to. I was in hotter circumstances, and could not let go."[30]

The work had equally clear affinities with contemporaneous Minimalism, in its serial rectilinearity and in particular in its industrial character. Like much 1960s sculpture, it was created not so much in the factory as in its shadow. When artists engage with the efficiency and scale of factory production, they

tend to focus on the incidents and accidents that occur along the way, not the products that come off the line. It makes sense: art is economically liminal. Those who make it typically imagine themselves standing to one side of conventional economic activity, offering an alternative sort of value. This brings a special meaning to their technical borrowings from industry—and not only in Minimalism. In her first years as a sculptor, Eva Hesse sourced her materials from a closed-down German textile factory. Toward the end of the decade, Robert Morris and Barry Le Va created immersive fields of industrial waste material. Further afield, there were Mark di Suvero and Anthony Caro, who employed a builder's vernacular. These processes were applied differently, though, always marking out a contrast with business as usual. As Bertoia's anecdote about the Waterbury foundry suggests, he too was attracted to the margin of industry. A writer for *Craft Horizons* noted of the Dulles panels, "It is putting to serious use the foundry-man's game of pouring out the metal at the end of the day and remarking on the free and evocative shapes it assumes in hardening."[31] *View of Earth from Space* was made on a factory floor, but, as those observers who gave it its title saw, it assumes a cosmic perspective. In this respect, too, the work echoes the Archimedean detachment of Minimalism, reframed in maximalist terms.

The inflection of industrial seriality is also important to Bertoia's famous kinetic sounding sculptures (tonals, gongs, and sounding bars) that he began making in 1960. As the art critic Jack Burnham noticed, "Seen in the context of other sculpture then in vogue," these were "staggeringly severe and cool to the touch."[32] For the most part, just like his diamond chair, the tonals were made of prefabricated rods and wires, in various alloys (part of his multivariable experimentation with motion, tone, and resonance). They are marvels of response, reacting to the touch just as his other sculptures, like the multi-panel screens and dandelions react to the va-

garies of light. They afford a sort of multi-sensory spatial engagement that is at once more commonsensical and more complete than the "theatricality" that Michael Fried famously located in Minimalism.[33] They could almost have been designed to fulfill John Cage's dictum "We must bring about a music that is like furniture."[34]

There is a film in which Bertoia's wife, Brigitta, is shown in the so-called Sonambient barn where Bertoia stored and displayed his sounding sculptures.[35] Instead of playing just a single sculpture, or a few of them, as one might expect, she strolls around the whole space, trailing her fingers along the vertical rods as she goes. The sound builds and builds and seemingly without end, the chiming, shimmering music layers atop itself into a thick aural stratigraphy. Though chaotic, it is the opposite of noise. The sounding sculptures embody Bertoia's maximalism in its maximum state: repetitive in their forms, industrial in their materiality, but containing infinite variation and ultimately aiming for transcendence.

Today, we tend to look back at Minimalism with mixed feelings. It inspires awe and impatience in equal measure, its radical reductiveness signifying both theoretical intensity and lordly disregard. It is, as Hal Foster has argued, a historical crux—an hourglass's throat that would not admit the expansive expressionism of previous art yet inaugurated the expansion of means. We should remember, though, that many artists never went down this restrictive rabbit hole, and Harry Bertoia was one of them. For all that his sculpture could be rigorous, even scientific, in its appearance, it extended itself in a wide embrace. He was a man who could walk into his studio every day, look around at the multiple possibilities that lay before him... and say yes.

1 Beverly Twitchell, email to the author, July 29, 2018. The exchange occurred in summer 1975. My thanks to Twitchell for sharing her thoughts and recollections on Bertoia's work.

2 Twitchell drew a comparison between Bertoia's "interest in repetition and rhythm" and that of the Minimalists in *Harry Bertoia: An Exhibition of His Sculpture and Graphics* (Allentown, PA: Allentown Art Museum, 1975), 8. See also Beverly Twitchell, *Harry Bertoia* (Huntington, WV: Marshall University, 1977). Twitchell's most recent book is *Bertoia: The Metalworker* (London: Phaidon Press, Ltd., 2019).

3 Bertoia in *Print* 9 (July 1955), 16.

4 I am not, here, proposing the word in the sense it was used by Robert Pincus-Witten in the 1980s. Pincus-Witten had coined the term "Postminimalism" as a descriptor for the process-based works of Eva Hesse, Robert Morris, Richard Serra and others, and clearly hoped to repeat that nomenclatural success. He used "Maximalism" to describe an exuberant pluralist mode, which others tended to understand as a strand within Postmodernism. As Scott Rothkopf has written, the term, "although suggestive, never quite stuck." See Scott Rothkopf, "The Diarist: Robert Pincus-Witten," *Artforum* 41, no. 7 (March 2003). See Robert Pincus-Witten, *Entries (Maximalism): Art at the Turn of the Decade* (New York: Out of London Press, 1983); Robert Pincus-Witten, *Postminimalism into Maximalism: American Art, 1966–1986* (Ann Arbor: UMI Research Press, 1987); and Sun-Young Lee, "The Critical Writings of Robert Pincus-Witten," *Studies in Art Education* 36, no. 2 (Winter 1995), 96–104.

5 James Meyer, "The Minimal Unconscious," *October* 130 (Fall 2009), 141–76:144.

6 *Bertoia: Recent Sculpture* (New York: Staempfli, 1968), n.p.

7 Ada Louise Huxable, "Banker's Showcase," *Arts* 29 (December 1, 1954), 13.

8 Wayne Craven, *Sculpture in America* (Newark: University of Delaware Press, 1984), 658–59.

9 J. K., untitled review of an exhibition at Staempfli Gallery, *Art News* 60 (May 1961), 48.

10 June Kompass Nelson, *Harry Bertoia: Sculptor* (Detroit: Wayne State University Press, 1970), 31.

11 Alice T. Friedman, *American Glamour and the Evolution of Modern Architecture* (New Haven: Yale University Press, 2010), 5.

12 Donald Judd, "Specific Objects," *Arts Yearbook* (1965).

13 Morris, "Notes on Sculpture, 1," in Morris, *Continuous Project Altered Daily*, 4.

14 Ibid., 14.

15 Anna Chave, "Revaluing Minimalism: Patronage, Aura, and Place," *Art Bulletin* 90, no. 3 (September 2008), 466–86:466. See also *A Minimal Future? Art as Object 1958–68*, ed. Ann Goldstein (Los Angeles: Museum of Contemporary Art, 2004); *Other Primary Structures*, ed. Jens Hoffman (New York: Jewish Museum, 2014).

16 Bertoia, "Reflections," in *Harry Bertoia: Recent Sculptures* (New York: Staempfli, 1978), n.p.

17 Meyer, "The Minimal Unconscious," 143.

18 See Michelle Kuo, "Industrial Revolution: The History of Fabrication," *Artforum* 46, no. 2 (October 2007), 306–15; Glenn Adamson and Julia Bryan Wilson, *Art in the Making: Artists and their Materials from the Studio to Crowdsourcing* (New York: Thames and Hudson, 2016), Chapter 7.

19 Interview with Charles I. Kratz, Johns Hopkins University, January 1966 (unpublished manuscript, Harry Bertoia Foundation), 8.

20 Eliot Noyes, *Organic Design in Home Furnishings* (New York: Museum of Modern Art, 1941); *Joris Laarman Lab* (New York: August Editions, 2017).

21 See Glenn Adamson, "Gatherings: Creating the Studio Craft Movement," in *Crafting Modernism*, ed. Jeannine Falino (New York: Museum of Arts and Design, 2011).

22 Charles Eames, "The Making of a Craftsman," Asilomar Conference Proceedings, American Craftsmen's Council, 1957; reprinted in Glenn Adamson, *The Craft Reader* (London: Berg Publishers, 2010), 578.

23 Robert P. Metzger, "Bertoia's Sculpture," in *In Nature's Embrace: The World of Harry Bertoia* (Reading, PA: Reading Public Museum, 2006), 12.

24 Twitchell, *Harry Bertoia: An Exhibition of his Sculpture and Graphics*, 8.

25 On gender performance and aggression in this era's art, see Anna C. Chave, "Minimalism and the Rhetoric of Power," *Arts* 64 (January 1990), 44–63.

26 The sculpture was demounted temporarily for an airport refurbishment and reinstalled in 2012.

27 Interview with Charles I. Kratz, 27.

28 Ibid., 28–29.

29 Ibid., 35.

30 Ibid., 34.

31 Lawrence Campbell, "Creative Casting," *Craft Horizons* 23, no. 6 (November–December 1963), 11–16, 48:48.

32 Jack Wesley Burnham, "Sculpture's Vanishing Base," *Artforum* 16, no. 3 (November 1967).

33 Michael Fried, "Art and Objecthood," *Artforum* 5 (June 1967).

34 For the complicated story behind this epigram, see Herve Vanel, "John Cage's Muzak-Plus: The Fu(rni)ture of Music," *Representations* 102, no. 1 (Spring 2008), 94–128.

35 The film can be seen online at https://www.youtube.com/watch?v=PNJXZSl5BfY.

Between Medium and Technology: Bertoia's Monotypes and the Synthesis of Art and Design

Sydney Skelton Simon

Before he was a furniture designer and a sculptor, Harry Bertoia made a name for himself in the art world as a printmaker. In the 1940s, working first in Michigan at the Cranbrook Academy of Art and then in Southern California, he made luminous, delicate, and carefully crafted monotypes, or single-impression prints.[1] He was represented by a prominent art dealer, Karl Nierendorf, and his work was shown in and collected by major museums across the United States. In many ways, his printmaking was foundational to his synthetic approach to art and design[2] and his experimental techniques anticipated the physicality of his sculpture and the complex interplay between object and image that unfolded through his cross-disciplinary practice. In the 1950s, as sculpture became his central pursuit, Bertoia explored forms and effects in his monotypes that would eventually find expression in three dimensions. The space of the page became a rich site of exploration and discovery for the rest of his career.

This essay poses an interesting challenge for the author: how does one write an essay focused specifically on one medium—the monotype—in the oeuvre of an artist whose body of work defies the strict categorization of medium-specificity? Indeed, over the years, Bertoia referred to his monotypes variously as prints, drawings, paintings, "Synchromies," and prototypes—typologies and techniques that overlap and even contradict one another. Bertoia's monotype practice embodies a profound *in-between-ness* that would come to characterize his whole creative practice: an irreconcilable and productive tension between the "purity" of non-objective art and the instrumentalization of industrial technologies and design for use.

Retreat into Non-Objective Purity

Bertoia's initial forays into monotype began, around 1940, as a "back door escape" from his teaching duties as an instructor of

metalcraft at Cranbrook Academy of Art in Bloomfield Hills, Michigan.[3] Since assuming control of the metal workshop as a scholarship student in 1937, Bertoia had been making finely crafted vessels and jewelry that demonstrated his facility with a range of techniques for shaping metal. His course offerings reflected the school's commitment to craft—an intimate familiarity with materials and processes of making—in the service of good design. Decorative objects like the hammered- and riveted-brass *Ornamental Centipede* (cat. 7) attest to his skillful handling of material, form, and process. He was also involved in a couple of major design competitions, including Eero Saarinen and Charles Eames's winning entries into the Museum of Modern Art's *Organic Design in Home Furnishings* competition. Bertoia's days at Cranbrook were consumed by the rigors of metalcraft and design for use; but in the evenings, he retreated to a world of pure image creation.

Initially, Bertoia made figurative woodcut prints, using techniques he had learned as a student at the Cass Technical High School in Detroit. But he grew bored with the fact that, but for subtle variations produced by modulating the amount of ink or pressure applied, the same image would be turned out of the press again and again. Bertoia's solution to the tedium of the exactly repeated image was to cut up the printing matrix, creating small blocks of wood in geometric shapes, the uncarved surfaces of which he inked and stamped directly on the page (cat. 15).[4] From this original act grew a body of work of almost magical properties: intimate compositions of luminous layers of ink, rolled and pressed onto delicate sheets of translucent paper.

Bertoia delighted in the flexibility and directness of this method of printing, placing geometric shapes and lines (which he stamped using the straight edges of his blocks) in dynamic relation with one another. He experimented with color, opacity, and repetition, often stamping his blocks multiple times on the tissue-thin paper without re-inking in between impressions. He began laying grounds of ink rolled unevenly with a rubber roller, called a brayer, directly on the page. Eventually, he introduced a smooth glass plate as a surface upon which to stamp. He would impress the image by laying a dampened sheet of paper over the inked plate and rolling a clean brayer across the verso of the page, or by simply applying pressure with his hands. This method of block printing enabled him to work directly and without the use of a printing press, which meant he could create his prints virtually anywhere.[5]

Initially, Bertoia had little art-historical context for the non-objective, or abstract, imagery he had stumbled into. He worked alone in the printmaking studio at Cranbrook: no formal instruction was offered, and there was no community of printmakers—nor even any abstract painters—encouraging his efforts. (Bertoia later recalled showing his monotypes to Eliel Saarinen, the president of Cranbrook Academy of Art, who advised him to stick with metalwork.[6]) But his confidence was bolstered by two sales to major museums: in early 1942, Bertoia sold a suite of 30 prints to the Wadsworth Atheneum in Hartford, Connecticut;[7] a year later, he sent 99 of his monotypes for critical feedback to Hilla Rebay, founding director of the Museum of Non-Objective Painting (now the Solomon R. Guggenheim Museum) in New York. Much to Bertoia's surprise, Rebay purchased the whole lot and dozens more in the months that followed, promising to make "constant exhibitions" of his work in the museum.[8] For ease of reference, Rebay gave Bertoia's monotypes descriptive and musical names, calling attention to his use of specific colors and shapes and to the rhythmic nature of the repeated stamped forms. Though they never met in person, Bertoia and Rebay carried on a spirited correspondence in which the elder doyenne of non-objective art offered her advice and criticism, sent texts and catalogues for Bertoia to read, and connected him with like-minded artists.[9]

With monotype, Bertoia could achieve effects impossible by any other means. While he rejected the exactly repeatable image of a stable matrix, he exploited other essential elements of printmaking: the use of pressure to transfer ink from one surface to another; repetition, reversal, and inversion; the possibility to work in series; and the matchless luminosity and clarity of the slow-drying printing inks. We see all of these attributes at play in one of the prints acquired by Rebay in 1943 for the Museum of Non-Objective Painting (cat. 12), in which Bertoia stamped oblique triangular blocks or paper shapes in fading sequences, creating a remarkable sense of depth as the intensity of the black ink diminished with each pressing. Bertoia likely used an unevenly inked brayer to create the atmospheric ground that frames the zigzagging shapes. Bright orange and yellow triangles and lines sit thickly on the page, their subtle dimensionality enlivening the composition. Though modest in size, Bertoia's jewel-like early prints were complex and layered, while retaining a sense of the immediacy and experimentation afforded by his stamping technique.

Two additional figures were influential as Bertoia gained a footing in the art world: the German art dealer Karl Nierendorf, who likely first saw Bertoia's monotypes in the galleries of the Museum of Non-Objective Painting, and the art historian Wilhelm Valentiner. From 1944 until his sudden death in 1947, Nierendorf cultivated a national reputation for the young artist by staging exhibitions of Bertoia's work in his New York and Los Angeles galleries and sending prints to museums across the country, including the Museum of Fine Arts, Boston, the Art Institute of Chicago, the Phillips Collection, and the San Francisco Museum of Art (cat. 20–22). Bertoia met Valentiner, then director of the Detroit Institute of Arts and an avid collector of contemporary European art, through his daughter: Brigitta Valentiner entered Cranbrook as a student in the fall of 1940, and after an extended courtship, she and Bertoia

married in May 1943. Through his father-in-law, Bertoia gained firsthand familiarity with important avant-garde art, especially the German Expressionists in Valentiner's collection. Many of Bertoia's early monotypes bear a striking formal resemblance to works by Paul Klee belonging to Valentiner, even though his techniques were radically distinct from Klee's paintings, drawings, and watercolors.[10] Valentiner, whom Bertoia affectionately called Papi, supported his artistic efforts, both intellectually and, later in the decade, financially.[11] Although Nierendorf first saw Bertoia's work in New York, it was Valentiner who likely introduced the dealer to his son-in-law in Detroit.

The rapid development of Bertoia's work in monotype was enabled by the United States' entry into World War II. Metal shortages caused the suspension of the metalcraft program at Cranbrook in 1942, leaving him ample time for his newfound creative outlet. But while Bertoia's monotypes were drawing praise in advanced art circles in New York, his usefulness as a teacher at Cranbrook was waning. In his final year, he taught two evening classes in printmaking to only a handful of students; his practice was deemed by the academy's leadership too idiosyncratic to support a full-fledged printmaking program. Thus, in the summer of 1943, Bertoia accepted a timely job offer from Charles Eames to move to Southern California and work for him in defense manufacturing. In this new setting on the front lines of industrial design, Bertoia began to frame his printmaking practice less as a retreat into non-objective purity and more as an active engagement with the conditions of advanced industrialization.

Drawing Is a Way of Learning
In California, Bertoia continued to experiment with a simple yet generative technique that he had first discovered in the basement at Cranbrook: he would lay a sheet of thin Japanese rice paper over an inked glass plate and draw on the verso of the page with

an improvised stylus, like a sharpened stick or metal palette knife. Wherever his stylus pushed the paper onto the plate, ink was lifted off the plate and embedded on the page, producing a sharp, linear drawing. The thinness of the paper allowed him to create fine, distinct lines while seeing only a vague picture of the image in progress through the wetted page. Areas of grainy shading were achieved by applying pressure either with a brayer, his fingers, or the heel of his hand. The final composition would be revealed only when the page was peeled off the plate—a moment of discovery for the artist. Bertoia often used this technique to work rapidly in series, incorporating ghosts and afterimages from previously pulled prints. Though he continued to use his block-printing technique throughout the 1940s, he increasingly turned to this method of drawing blindly through the page to feel his way to an image.

Bertoia's professional experiences in Southern California had a profound impact on how he thought about his monotypes. Working for Eames in the Molded Plywood Division of the Evans Product Company, Bertoia helped to develop and manufacture splints and airplane parts for the war effort, with an eye toward the peacetime application of molded plywood and related technologies to modern furniture. In a literal sense, Bertoia's monotypes neither used nor made reference to technological processes: his abstract doodles and block prints seldom depicted the *things* of the Machine Age, and his emphatically artisanal process required little in the way of specialized equipment. But in the new creative community of artists, architects, and designers of the Molded Plywood Division, Bertoia began to frame his prints in relation to advanced technology, drawing an explicit connection between his way of working and the concerns of contemporary industrial design.

Emblematic of Bertoia's shifted frame of reference is a two-page spread published in the April 1944 issue of *Arts & Architecture* magazine that featured several monotypes made using his technique of composing lin-

ear drawings through the verso of the page (fig. 1). Eight compositions of concentric linear shapes march across the two-page spread like a film strip, suggesting the limitless—even relentless—possibilities of his tactile approach. An evocative artist's statement accompanies the printed images, in which Bertoia states:

> Drawing is a way of learning.
> A way of finding a truth. A line
> commences somewhere, gathers
> momentum, spends its energy and
> comes to an equilibrium equiva-
> lent to a life-cycle. It could also be
> said that it establishes its norm
> of balance and dimension. I draw
> what I don't know in order to learn
> something about it. Electro tubes
> are extensions as well as magnifi-
> cations of our senses. Neither our
> senses nor the tubes can be faked.
> They wouldn't work. The same
> physical laws that condition the
> existence of the tube are at work
> in a drawing, if it is to be any good.
> There is no place for nonconstitu-
> ents. Each and every part is so in-
> tegrated that a change by removal
> or addition would be destructive.
> Objects can change their form
> without changing their dimension.[12]

Bertoia emphasizes the utility of his method of printmaking as a means of exploration and discovery ("Drawing is a way of learning"), while also drawing a provocative analogy to "electro tubes" as extensions and magnifications of the senses. He was most likely referring to electron or vacuum tubes, which were vital elements in modern mass-communication systems that served to amplify sound waves as they traveled across great distances in telegraphic, telephonic, and radio signals.

Also called repeaters, electron tubes offer an apt metaphor for Bertoia's printmaking because of the way they reproduce and amplify signals. Inside a vacuum-sealed

Drawing is a way of learning. A way of finding a truth. A line commences somewhere, gathers momentum, spends its energy and comes to an equilibrium equivalent to a life-cycle. It could also be said that it establishes its norm of balance and dimension. I draw what I don't know in order to learn something about it. Electro tubes are extensions as well as magnifications of our senses. Neither our senses nor the tubes can be faked. They wouldn't work. The same physical laws that condition the existence of the tube are at work in a drawing, if it is to be any good. There is no place for nonconstituents. Each and every part is so integrated that a change by removal or addition would be destructive.
Objects can change their form without changing their dimension.

HARRY BERTOIA

Fig. 1
Two-page spread, "Harry Bertoia," *Arts & Architecture* (April 1944): 22–23.

chamber, a positively charged plate attracts electrons from a filament. Between them, a grid carrying alternating positive and negative currents has the effect of multiplying the electrons passing from the filament to the plate. Consequently, charges passing through the grid produce greatly magnified images of themselves on the plate. The glass chamber had to be vacuum-sealed (or evacuated of "non-constituents," to borrow Bertoia's language) because any air molecules in the tube would restrict the free flow of electrons.

By invoking electron tubes, Bertoia likened his printmaking process to a system of electronic communication wherein signals passing from the artist through the page are repeated and amplified. The expressive content of a line is governed by not arbitrary whims but physical laws that cannot be faked. A monotype sold to the Art Institute of Chicago by Nierendorf offers a compelling visual summation of the forces at play in this statement about Bertoia's practice (cat. 20). Against a silvery ground of ink rolled onto a smooth plate with a brayer, Bertoia has drawn, through the verso of the page, a series of dynamic lines that bend and splay in an approximation of a human figure that recalls Paul Klee's pinwheeling *Dancer* of 1930, which Bertoia saw illustrated in black and white in a catalogue of Klee's paintings published by Nierendorf's gallery in 1941[13] (fig. 2). Bertoia's abstracted figure—reversed in the printing process, its limbs shattered and reverberating—literalizes the idea of drawing as energetic transmission, offering a vision of the artist as (electrical) conduit. In place of Klee's skeletal hands and feet, the extremities of Bertoia's figure spiral outward like broadcasting radio towers. After lifting the print from the plate, he used the inked edges of a wooden block to stamp an additional set of white lines onto the surface of the composition that catch light and create a sense of movement flickering across the page.

Bertoia's printmaking process was about as "low tech" as possible, and his monotypes were much more carefully handcrafted than he lets on in this statement. But in likening his method to the functioning of an electron tube, he was able to connect his artisanal work to the concerns of contemporary industrial design. Drawing via printmaking had become, in Bertoia's proto-cybernetic articulation, a process, an action, and even a technology, as opposed to a completed or finished thing.[14] By describing his process as automated and mechanized, Bertoia had, in his own way, assimilated the conditions of mass production into a technique that could create new and ever-varied results.

Bertoia's printmaking techniques did not radically change with his arrival in California; what changed was how he framed his practice. His second appearance in *Arts & Architecture* magazine, a year later, would again stress the machine-like production of his prints. In it, he is quoted: "The path of action becomes important, the scribbled page becomes something like a by-product."[15] By characterizing his monotypes as scribbled pages and by-products, he stressed the mechanical inevitability of the monotypes and downplayed the degree to which each image was carefully considered and embellished.

Object as Image, and Image as Object

Figuration crept into Bertoia's monotypes in a variety of ways by the mid-1940s. Several linear prints seem to evoke electronic circuitry (cat. 33), while others allude to his interest in science and nature. One exceptional print, numbered 70A by Brigitta after the artist's death, is especially intriguing for the way it stages a confrontation between different modes of representation (cat. 32).[16] An atmospheric haze of muted black, brown, and green tones conjures the infinite depth of a night sky. Various floating forms and flying contraptions, most rendered schematically, encircle an exploding light source near the center of the composition. Curving white lines indicate the ghostly afterimage of a cognate print previously pulled from the same plate. As our eyes scan the page, sev-

Fig. 2
Paul Klee, *Dancer (on Yellow)*, 1930,
black-and-white reproduction of a
watercolor in Karl Nierendorf, ed. *Paul
Klee: Paintings Watercolors 1913 to 1939*
(New York: Oxford University Press and
Nierendorf Gallery, 1941), plate 28.

eral marks refuse to cohere to the sense of deep space. A large arrow, labeled "arrow," points to a sequence of outlined shapes moving from circle to ovoid into the upper left corner, and then dropping back toward the center. Above the sequence, a line of text reads, from right to left, "Gas mass under increasing rotational velocity" **(fig. 3)**. Another snatch of text emerges in the lower right of the picture beneath a segmented triangle: "Retractable." We are dealing, it seems, with the visual idiom of diagrams set free in the cosmos.

Schematic renderings like those in monotype 70A would fill Bertoia's days at the

Navy Electronics Laboratory (N.E.L.) at Point Loma, near San Diego, where he worked as a technical and scientific illustrator after leaving the Molded Plywood Division. From 1947 to 1950, Bertoia worked in the Visual Development Division on graphics, photography, and layouts for technical reports and instruction books, tasks that appealed to his longstanding interest in the ways in which scientific principles are illustrated. But whereas his job at the N.E.L. required that he combine image and text to communicate a concept unambiguously, the various elements in monotype 70A operate in disparate and conflicting planes of signification. The

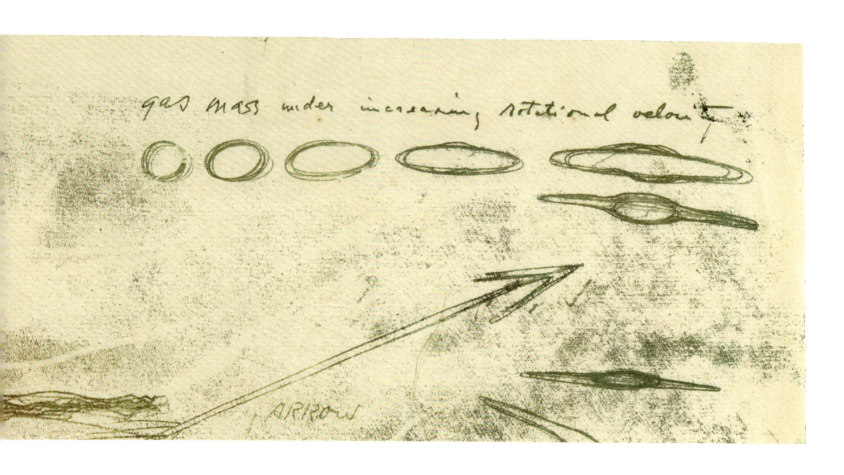

Fig. 3
Detail of monotype 70A, showing upper left quadrant
flipped horizontally so that text ("gas mass under
increasing rotational velocity") is legible.

sequence in the upper left corner, its source likely a diagram of stellar rotation, drops down the side of the print as the ovoid transforms into a flying saucer.[17] The arrow, a mark that would seem to be exclusive to the graphic field, is echoed in the adjacent rocket ship, apparently headed in the same direction. The text appears in reverse because Bertoia annotated his monotypes in the printing process, making it difficult to read unless the viewer turns the page over and holds the print up to the light. The slippages and transformations of text and image undermine their clarity—the content of what is communicated—but in so doing call attention to the mode of address. We recognize the scribbles as text even if we can't read them, and we might even assume that Bertoia wrote for his own benefit and not for ours. Indeed, he would routinely insert notes to himself in his later prints, describing light effects or metalworking processes next to various explorations of sculptural forms.

The inclusion of these diagrammatic elements reminds us of Bertoia's process of drawing *through* the page, and that the marks in the monotype are registrations of a body and mind at work. They highlight the materiality of the monotype as a physical by-product of a course of action and of the interaction between an artist, his medium, and the development of his ideas therein. If drawing was a way of learning for Bertoia, then in monotype 70A we see him actively interrogating the very structures by which ideas are communicated visually. This interplay between object and image, and between the sensation of depth and the flatness of the graphic plane would be fundamental to the conception of the chairs he designed for Knoll and to his larger sculptural practice, which traded on the tactility of worked metal and its impact as a flat, and reproducible, image.

Print as Prototype

By the early 1950s, as Bertoia turned his attention to welded metal sculpture, his earliest efforts in printmaking seemed, in retrospect, to have anticipated his experiments in three dimensions. In 1950, he referred to his block prints as "prototypes," a clever alteration of the term monotype that retains the print's singularity while suggesting that the images serve as preliminary exercises or models for future work.[18] In an interview published in *Architectural Forum* in 1952, Bertoia describes his earliest block prints (which he calls paintings) as if they were studies for his sculptural screens and wire chairs:

> *I used to make paintings on the most transparent paper I could find—paint just a shape here, leave a lot of space around it, and then another shape and another color there. Then I would stretch the paper on a frame and hang it up against the light. The colors would float in the air, some closer, some farther back.*[19]

In hindsight, it is hard not to see the formal resonances between the floating squares on transparent paper and his planned screen for the Lambert–St. Louis Airport a decade later (cat. 14 and p. 194). In the early 1950s, Bertoia returned to block printing to create compositions that explicitly referenced his multiplane sculptural screens, evoking the rich textures of his brazed metal plates in colorful pressed ink (cat. 45).

Throughout the 1950s, Bertoia increasingly used the printed page as a space for exploring sculptural forms. Rows of figures drawn through the verso of the page on strips of paper cut to panoramic proportions indicate both the speed at which Bertoia could rehearse such ideas before committing them to

metal and the charm of imagining his sculptural forms populating a fantastical landscape (cat. 47–53). Several of the monotypes featured in this exhibition relate to specific sculptural commissions. One corresponds to a suspended, melt-coated brass piece made for the Genesee Valley Mall in Flint, Michigan, in 1970 (cat. 66 and p. 206). Yet another print evokes the fountains that Bertoia made in the 1960s and 1970s of welded copper tubes, as in his commissions for the Philadelphia Civic Center; the Manufacturers and Traders Trust Company in Buffalo, New York; and for Marshall University in Huntington, West Virginia (cat. 86 and pp. 204, 206, 207). Monotypes capture both the extraordinary fluidity of the proposed sculpture's undulating surfaces and the meticulous articulation of its construction out of noodle-like metal tubes.

Bertoia was by no means the only direct-metal sculptor to work out his designs on paper before executing them in metal. The founding trope of the medium, as coined by the Catalan artist Julio González, is that welding enables the artist "to draw in space," so it is only natural that many artists would first conceive of their sculptures as sketches on paper.[20] But it is extraordinary that Bertoia went to the trouble of sketching in monotype, cultivating graphic effects specific to the medium. He could capture not only the form but also a sense of the energy and atmosphere of his metal sculptures and installations. A monotype featuring a bursting dandelion shape emerging from a fountain—related to his 1962 commission for Edward Durell Stone's Perpetual Savings & Loan building in Los Angeles—exploits the capacity of his printing techniques to evoke the glow of the sculpture, the misty spray of the water, and the reflection of light on their surfaces (cat. 67 and p. 201). By the 1960s, he was creating his prints entirely through the verso of the page, rarely embellishing the images after pulling them from the plate. He embraced accidents and chance effects as inspiration for new avenues of inquiry, both on paper and in three dimensions.

In a lantern-slide presentation delivered at the International Design Conference in Aspen, Colorado, in 1955, Bertoia projected a monotype that he identified as a "map" or "genesis" of his "World of Art." He explained to the audience,

> It is from this single graphic that I find an endless source of suggestions for growth and development. In its accidentals I find, as in Nature, sublime rationality that brings forth what is truly most enjoyable.[21]

Exactly which image provided Bertoia with such a deep well of inspiration remains a tantalizing mystery, but its stated importance confirms the centrality of his monotypes to his creative practice as a whole.[22] Indeed, its absence from the record provides a clearing to imagine that any and all of his monotypes might provide such a map to Bertoia's "World of Art." His embrace of monotype—a mode of image-making that occupies, as Jennifer Roberts has noted, "an ineffable space between painting, drawing, and printing"—set the stage for a career-long interest in working between and across media.[23]

1 There is some confusion about terminology when it comes to describing Bertoia's prints. I feel that "mono-type" is most appropriate, because it implies a printed image in which the source matrix is unfixed and therefore degraded or destroyed in the act of printing. A monoprint typically refers to a unique print made from a repeatable matrix but where some alterations to the printed image have been made by hand. June Kompass Nelson, who wrote a monograph about Bertoia's printmaking practice, invented a new term, "monographics," to describe this body of work. Though I do not adopt her terminology, Nelson's meticulously researched catalogue has been invaluable to my understanding of Bertoia's printmaking practice. June Kompass Nelson, *Harry Bertoia, Print-maker: Monotypes and Other Monographics*, exh. cat. (Detroit, MI: Wayne State University Press, 1988).

2 I argue this point more fully in my dissertation, the first chapter of which claims a central role for the monotypes in Bertoia's navigation of the competing aims and claims of Modernist art and design at mid-century. Sydney Skelton Simon, *Harry Bertoia and Postwar American Design Culture*, Ph.D. dissertation, Stanford University, 2018.

3 In a 1970 interview, Bertoia explained, "That was my back door escape as I say. I felt as long as there were metal craft students, it was my duty to be present with them, during which time I did my own work too. But in the evening I discovered printmaking." Interview transcript in Susan Joyce McGhee, *Influences Affecting the Nurturing of the Artist-Craftsman – Harry Bertoia*, A Thesis in General Family Studies, Pennsylvania State University Graduate School, March 1971, 87–88.

4 Bertoia relayed this origin story about his initial experiments in monotype in his oral-history interview with Paul Cummings for Archives of American Art. Oral-history interview with Harry Bertoia, June 20, 1972, Archives of American Art, Smithsonian Institution, page 8 of the transcript.

5 In an essay about Jasper Johns's monotypes, Jennifer Roberts refers to the brayer as "a kind of mobile, minia-ture press cylinder," an especially apt description in light of Bertoia's eschewal of the hulking stationery press. Jennifer L. Roberts, "The Metamorphic Press: Jasper Johns and the Monotype," in Roberts and Susan Dacker-man, *Jasper Johns: Catalogue Raisonné of Monotypes* (New Haven and London: Matthew Marks Gallery and Yale University Press, 2017), 15.

6 As recorded in notes from an interview with Bertoia, conducted May 18, 1978, by Joan Lukach and Susan Ferleger, Hilla von Rebay Foundation Archive, M0007, Box 004017, folder 2, Solomon R. Guggenheim Archives, New York.

7 In a letter dated January 16, 1942, Bertoia wrote to Arthur Everett "Chick" Austin, Jr., the director of the Wadsworth Atheneum, "I desire to write you this letter and tell you of my deep satisfaction in learning … that one set of color prints was purchased by your museum. This is an honor and a rare priviledge [sic] distinguished by being *the first concrete sign of encouragement* in the estimation of that type of work." Emphasis added. Registrar's file for *Synchromy No. 5* (1942.337.1-30), Wadsworth Atheneum, Hartford, CT.

8 Letter from Rebay to Bertoia dated March 11, 1943, in "Business Records – Solomon R. Guggenheim Foundation (1943–1945)," Harry Bertoia Papers, owned by Vitra Design Museum; microfilmed by Archives of American Art, Smithsonian Institution, reel 3846.

9 For a sampling of the letters they exchanged, see Joan M. Lukach, *Hilla Rebay: In Search of the Spirit in Art* (New York: George Braziller, 1983), 148–51.

10 Reviewers of Bertoia's solo exhibitions at the Nieren-dorf Gallery in New York remarked upon the apparent influence of Klee's work on his imagery. See Maude Riley, "Monoprints by Bertoia," *The Art Digest* 19, no. 9 (February 1, 1945), 19; and "Harry Bertoia [Nierendorf]," *Art News* 46, no. 3 (May 1947), 48.

11 Shelley Selim has written about the apparent influence of Valentiner and Neovitalism on Bertoia's monotypes in the 1940s in *Bent, Cast & Forged: The Jewelry of Harry Bertoia*, exh. cat. (Bloomfield Hills, MI: Cranbrook Art Museum, 2015), 16–19.

12 "Harry Bertoia," *Arts & Architecture* 61, no. 4 (April 1944), 22–23.

13 *Paul Klee: Paintings, Watercolors 1913 to 1939*, ed. Karl Nierendorf (New York: Oxford University Press, and Nierendorf Gallery, 1941), 28. The *Dancer* was reproduced in black and white in Nierendorf's spiral-bound catalogue, such that the ground, yellow in the original, appears to readers as a mottled silvery-gray. In a letter dated December 6, 1943, Bertoia reports to his father-in-law, Wilhelm Valentiner, "Karl Nierendorf has written to me offering to buy, exhibit or publish a portfolio or book from some of my drawings, hinting that he would like to collaborate with me on the same bases [sic] as he did with Klee." Wilhelm Reinhold Valentiner Papers, owned by North Carolina Museum of Art; microfilmed by the Archives of American Art, Smithsonian Institution, reel 2141.

14 Bertoia's statement anticipates Norbert Wiener's comparison of the human nervous system and electrical systems with vacuum tubes in his *Cybernetics, Or Control and Communication in the Animal and the Machine* (New York: John Wiley & Sons, Inc., 1948), 141–42.

15 Harry Bertoia, "The eighty-four drawings..." *Arts & Archi-tecture* (May 1945), 22–23.

16 Brigitta Bertoia numbered most of the nearly 2,000 monotypes by Bertoia that remained in the artist's estate after his death in 1978. The numbers were assigned arbi-trarily (likely in the order that she came to them), without consideration to chronology, size, technique, or subject matter. Because the vast majority of Bertoia's prints were untitled, this numbering system is a helpful way to identify prints that Bertoia did not sell or give away during his lifetime.

17 The galactic imagery of monotype 70A reflects the artist's special interest in astronomy. In 1944, he and Brigitta began attending monthly lectures at the Griffith Observatory in Los Angeles, and they purchased the six volumes of the Harvard Books on Astronomy. See Nelson, *Harry Bertoia, Printmaker*, 41. I suspect this diagram of stellar rotation was sourced from a book or article, though I have not yet identified which one.

18 Bertoia used the term "prototype" to describe his block-printing technique in a questionnaire he filled out in 1950 for Henry Rasmusen, who was preparing a manuscript for an important survey of the medium of monotype, published in 1960. Quoting Bertoia, Rasmusen writes, "Bertoia's ways are many, 'invention of means according to problem' being his creative standard, but his best-known approach is called by him, 'prototype,' which consists of building up a painting in fairly thick pigment by applying it in gradual steps from cutout shapes made in cardboard, wood, and other materials." Henry Rasmusen, *Printmaking with Monotype* (Boston: Chilton, 1960), 50. Rasmusen's original inquiry and questionnaire are saved in "Business Records – Requests for Information by Au-thors and Publications (1949–1967)," Harry Bertoia Papers, reel 3849.

19 "Pure Design Research," *Architectural Forum* 97, no. 3 (September 1952), 146.

20 See Margit Rowell, *Julio González: A Retrospective*, exh. cat. (New York: The Solomon R. Guggenheim Museum, 1983), 13; Rosalind E. Krauss, "This New Art: To Draw in Space" (1981), in *The Originality of the Avant-Garde and Other Modernist Myths* (Cambridge, MA: The MIT Press, 1985), 119–29.

21 Bertoia's remarks on "Light and Structure," along with papers by eighteen other speakers at the 1955 Inter-national Design Conference in Aspen, were published in *Print* 9, no. 6 (July–August 1955), 16–17. A copy of his typewritten remarks in a conference folder is also saved in Harry Bertoia Papers, 1917–1979, Archives of American Art, Smithsonian Institution.

22 William de Mayo, another panelist in Bertoia's session at the International Design Conference in Aspen, asked him to clarify what he meant by his "world of art" graphic, having missed his lantern-slide presentation the evening before. Bertoia explained, "It happens to be one single page, rather large, on which many years ago I simply scribbled a number of lines and tones, not knowing exactly what I was doing but having somehow a thought or direction and I kept it and throughout this space of time it has been a source of suggestion as if I would take a walk to find a similar suggestion from nature. In other words, by now it has become—and its suggestions have not yet been exactly exhausted yet—I still look into it and find possible further explorations." Transcript of Session III, International Design Conference in Aspen Records, 1949–2006, The Getty Research Institute, Los Angeles, Accession no. 2007.M.7, box 2, folder 3, 105–06.

23 Roberts, "The Metamorphic Press," 15.

"The Moment of Sharing":
Harry Bertoia's Large-Scale Commissions

Marin R. Sullivan

Between 1953 and his death in 1978, Harry Bertoia executed more than fifty large-scale commissions—here meant to designate a sculpture or a group of sculptures made for a specific architectural or outdoor civic project, often in close collaboration with the architect or client. He installed these works in lobbies, office interiors, banking floors, shopping-mall courts, libraries, performing-arts centers, universities, airports, and even one private residence, in cities across the United States as well as Belgium, Germany, and Venezuela (fig. 1). He received more requests than he could handle, usually due to scheduling conflicts—though sometimes he deliberately chose to decline the offer. In addition, a number of accepted commissions fell through because of funding issues or bureaucratic conflicts.

Distinct from Bertoia's works selected for specific interiors, installed or relocated after the fact, gifted by the artist for a site, or made directly for smaller domestic spaces (of which there are hundreds more), the large-scale commissioned sculptures became a core aspect of his artistic practice. These projects gave Bertoia a high-profile platform to share his work. They provided economic stability and enabled him to work as an independent artist, without any teaching or major gallery obligations. This type of work also allowed him to be ambitious and to experiment with new materials, techniques, and dimensions.

Bertoia's large-scale commissions were inherently transactional—sculpture created because he was asked, selected, or hired to do so. Many were closely aligned with commerce and possessed a decorative function; all involved attending to the needs of clients. These qualities became anathema to the definition of a serious modern artist, and, in part, account for Bertoia's marginalization within that standard art-historical narrative. He was hardly alone, however, in such pursuits during the mid-twentieth century. Artists like Alexander Calder, Richard Lippold, Henry Moore, Louise Nevelson, and Isamu Noguchi, to name but a few, took on similar commissions and in the process offered a new understanding of how modern, abstract sculpture could function within the public sphere. To examine Bertoia's

Harry Bertoia, *Untitled (Multi-Plane Construction),* 1954 (detail), Manufacturers Trust Company, 510 Fifth Avenue, New York, NY.

large-scale commissions is to engage with an all-too-often-overlooked aspect of postwar American art history, but it also reveals a fundamental feature of his artistic practice: the importance of a collaborative spirit, of working together to achieve tremendous results, and facilitate intense connections through publicly accessible sculpture.

Cooperation, functionality, and interconnectivity became central tenets of Bertoia's practice and informed every large-scale commission he realized. These ideas, as well as his willingness to seek out collaborators from across disciplines, were fortified if not shaped by his time at the Cranbrook Art Academy, where from 1937–43 he was a student and then a teacher of metalwork and printmaking. A part of the Cranbrook Educational Community and modeled after the Bauhaus, the Art Academy became one of the most import-

ant incubators of design talent in the United States during the mid-twentieth century. The noted Finnish architect Eliel Saarinen had designed the campus in 1925 at the request of the publishing magnate George Booth and became the school's first president.[1] American architecture and design following World War II was both small and intrinsically international, with many practitioners having emigrated from Europe or having been trained by those who had. They taught and established significant programs at a handful of institutions, including Cranbrook, the Illinois Institute of Technology, the Massachusetts Institute of Technology, and the Yale School of Architecture.

Under Saarinen, Cranbrook gained a reputation for being a "creative center for artists, architects, and designers" that encouraged experimentation and "cross-fer-

tilization across disciplines."[2] The mixture of strong work ethic, open exchange, and artistic exploration during the early years of the school produced an extraordinary group of alumni and staff that included Bertoia, Charles Eames, Ray Eames (née Kaiser), Florence Knoll Bassett (née Schust), Eliel's son Eero Saarinen, Marianne Strengell, and Harry Weese. As critic Wolf Von Eckardt suggests, these artists, architects, and craftspeople redefined what good modern design in America meant through an evolutionary approach, creating "not with dogmas or preconceived notions, but by almost playful experimentation with traditional craftsmanship and styles."[3]

Bertoia was largely involved as a student and instructor with metalwork while at Cranbrook, but no course of study was isolated at the school. He spent much of his time in the architectural department, where he befriended and collaborated with Eero Saarinen, who officially served as an assistant and instructor in the advanced architecture department run by his father, and Charles Eames, who was an architec-

Fig. 2
Harry Bertoia, Marjorie Cast, Charles Eames and Benjamin Baldwin at Cranbrook Art Academy, 1938.

ture student and design faculty member
(fig. 2). Bertoia helped construct models and
prototypes, including Saarinen and Eames's
famous submission to MoMA's 1940 *Compe-
tition for Organic Design in Home Furnishing*,
and would go on to work at the Eames's
studio in California in the mid-1940s. Ber-
toia described his time at the school as "so
important that I feel it was one of the basic
periods of my life where things began really
to change and happen."[4]

The personal friendships and profes-
sional connections Bertoia forged while at
Cranbrook would last his entire life. Florence
Knoll—who was, as *The New York Times*
declared in 1964, "the single most powerful
figure in the field of design"—would prove
a crucial collaborator and connector within
Bertoia's career[5] (fig. 3). Along with her hus-
band, Hans Knoll, she offered Bertoia a po-
sition with Knoll Associates in Pennsylvania
in 1950—a role that famously led to the cre-
ation of the Bertoia Collection of wire chairs
in 1952.[6] His relationship with Knoll, however,

also provided numerous opportunities to
create and display sculpture. Knoll show-
rooms, including the flagship at 575 Madison
Avenue in New York (fig. 4), frequently exhib-
ited his work, and the Knoll Planning Unit,
founded and led by Florence Knoll, often
integrated Bertoia's sculptures into interior
design schemes.

Bertoia's work with Knoll also directly
led to some of his earliest and most sig-
nificant large-scale commissions. These
projects and the chairs should not be un-
derstood, however, as disparate parts of
his practice. Furniture, like sculpture, was
seen as an increasingly integral aspect of
mid-century modern architecture, "no lon-
ger at the inconspicuous periphery but in
the *center* of a space cleared of distract-
ing clutter."[7] Bertoia, Knoll, and Saarinen
demonstrated this holistic approach to
design in 1953, when they worked together
on the General Motors Technical Center in
Warren, Michigan. The Knoll Planning Unit
was responsible for the interior design of

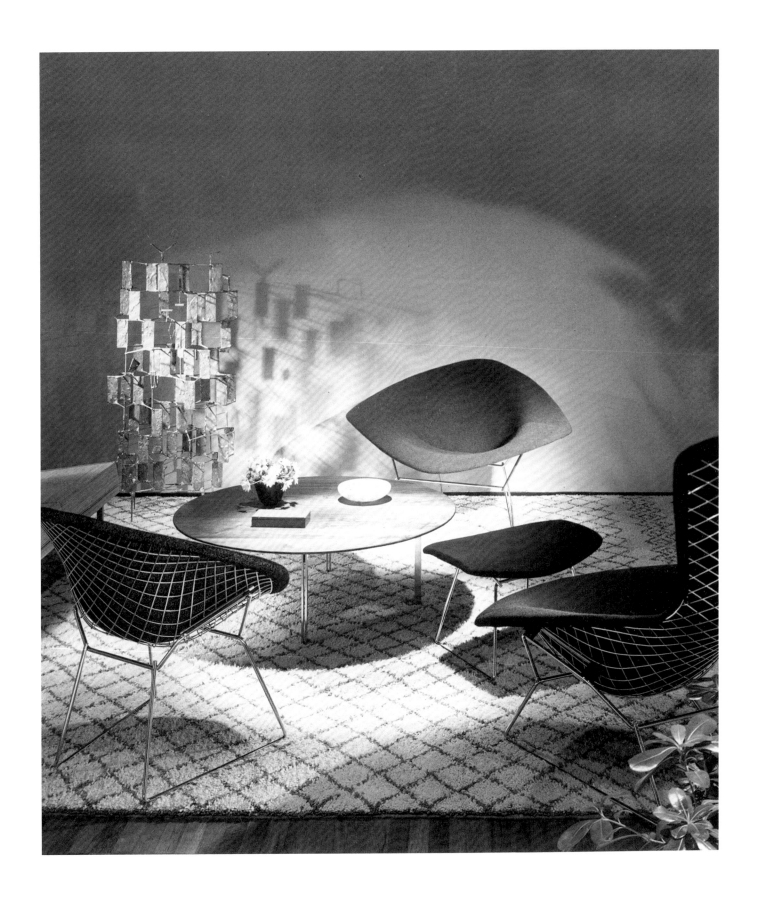

Fig. 4
Harry Bertoia's Diamond Chair and Bird Chair.

Fig. 5
Interior of the Central Restaurant
Building at the GM Technical Center.

much of the sprawling, 320-acre suburban campus just north of Detroit, which had occupied Saarinen and his firm since the late 1940s. The architect remained invested in Bertoia's activities long after they had both left Cranbrook. After seeing an exhibition of his chairs and freestanding metal sculptures at the New York Knoll Showroom in 1952, Saarinen asked Bertoia to create a work for the cafeteria in the Central Restaurant Building at the GM Technical Center.[8]

The resulting sculpture (fig. 5), a welded metal screen approximately 36 feet long, contributed much to the space, but seemed, in retrospect, more successful as a learning experience for Bertoia in how to incorporate his sculpture within a larger architectural context. The artist remarked how dramatically the work changed after he installed it, owing largely to the fact that the sculpture ended up far away from the window in the cafeteria. The lighting, or lack thereof, transformed the screen into more of an inert silhouette, with little light reflecting across its various panels. While Saarinen and the GM clients were by all accounts happy with the outcome, the artist's own dissatisfaction with the work after it was installed can, in part, be attested to his never before having worked on such a large scale. As Bertoia later recalled of Saarinen, "He was the first one who really risked asking me to do something in that scale. I was unknown and untried but he knew me personally and he probably knew what he might expect. At any rate that was the first commissioned work and it seems that it brought me to the attention of the architectural profession so from there on I never lacked in being asked by one director or another to do something."[9]

Over the next twenty-five years, Bertoia would indeed be regularly approached by architects to create sculpture for their projects. During the postwar period, the renewed synergy between art and architecture (or at least the widespread attempt at synergy) was relatively short-lived and rarely an easy partnership of equals.[10] For

cross-disciplinary collaboration to succeed —for art to function as more than the "intellectual application of decoration to the surface of a building"—architects and artists would have to simultaneously and organically work together.[11] Bertoia was fortunate enough to find architectural counterparts willing to try. He collaborated with Gordon Bunshaft, Woodward "Woodie" Garber, Victor Gruen, I. M. Pei, Kevin Roche, Saarinen, Edward Durell Stone, Thomas T. K. Zung, and Minoru Yamasaki on multiple occasions over multiple decades.

Bertoia worked with Yamasaki alone on six distinct commissions, creating seven large-scale sculptures over two decades: from the unusual, colorful screen for the Lambert–St. Louis Airport in 1955 to the two-part tonal fountain in front of the Federal Reserve Building in Richmond, Virginia, in 1978. There were also a number of unrealized projects, including the Bertoia-designed playground equipment for Yamasaki's Detroit University School and Grosse Pointe Country Day School, and the smaller-scale works the architect asked the sculptor to create for his residence in Bloomfield Hills, Michigan.[12] The mutual respect between the two practitioners is evident from an interview they gave in conjunction with the dedication of Bertoia's sculptural fountain for the Manufacturers and Traders Trust Company (M&T) Plaza in Buffalo in 1968. Yamasaki stated, "Harry deeply believes in his creations, and understands what technology means. He gives full expression to the idea of man the master over machine. I firmly believe that you must bring the aspirations of man to the eyes of man." Bertoia responded, "To delight a city or a nation, that's great. It comes to a full flower when you are given the chance to do this kind of collaboration."[13]

Yamasaki, like many of his colleagues most keen to commission artists like Bertoia to create large-scale works for their projects, was one of the so-called second-generation Modernists. These architects of

6'-0"

1'-0"

5'-0" 5'-0" 5'-0"

15'-0"

sculpture

CHAIRMAN OF THE BOARD
WAITING & SECRETARY

Fig. 6, 7
Sketch of Sentry Insurance Headquarters and
architectural drawing of executive suite.

the postwar period were both lauded and criticized for their emphasis on aesthetic concerns and embrace of ornament during a moment when the formal austerity of the International Style still reigned. The architecture of Saarinen, Stone, and Yamasaki, for example, was seen by many critics at the time as too decorative, too sculptural, and, much like Bertoia's work, could thus be dismissed as nothing more than, as noted architectural historian Vincent Scully wrote, "brightly colored bundles, gaudily bowed to catch the blearing eye."[14]

The prominence on aesthetic, humanist functionalism in both art and architecture of mid-century Modernism is apparent in the archival records of Bertoia's large-scale commissions—whether in the justifications to clients as to why his sculptures should be commissioned, or the responses of the architects to what he produced. For example, in a letter to an executive at the Manufacturers and Traders Trust Company in Buffalo, New York, Yamasaki wrote, "As I have found with other artists, his propaganda is somewhat disorganized, however, I believe that he would do a beautiful fountain for you and can assure you that he would work with us in achieving a piece most appropriate for the building."[15] Or in a letter Stone sent to Bertoia following the dedication of his Chicago commission in 1975: "I think the things you have done to The Standard Oil Building are beautiful and I am very happy indeed."[16] Bertoia's large-scale commissions were made to be lovely, striking sculptural things; but architects repeatedly commissioned his work because they also complemented, elevated, and activated their designs.

The relationships Bertoia cultivated with noted Modernist architects served as a model for how creative synergy could be achieved. Substantive collaborations were usually best served when the artist was brought on early in the design process and given as much access to the specifics of a given site as possible. In Bertoia's case, this exchange often occurred through exten-

sive correspondence. The early stages of the commissioning process usually involved Bertoia sending the architect sketches of possible works, photographs of previously realized projects, and detailed installation guidelines or needs (fig. 6, 7). Architects, in turn, sent him blueprints and drawings, numerous photographs of the site or building under construction, and extensive descriptions of planned interior surrounding spaces.

Often this correspondence expanded to include the whole project team—other architects, project managers, engineers, lighting designers, etc. For Bertoia, it was not simply about making sure the aesthetics or form of his sculpture fit and responded well to the architectural design, but also that it could be properly fabricated, installed, and lit within the space. During the creation process of *Sunlit Straw*, which served as a focal point in the lobby of the downtown headquarters of Northwestern National Life Insurance in Minneapolis, Minnesota, Bertoia frequently corresponded with Alvin Prevost, another architect at Yamasaki's firm. They discussed in great detail how the sculpture should be anchored, how lights should be installed in the ceiling around it, and even how the contractor and project manager could temporarily remove the glass in the lobby to accommodate the various sections of the work entering into the space.

Bertoia, when possible, also visited building sites before, during, and after construction and frequently was there for the installation of the final work. Architect Bennett Johnson, who commissioned him to create a large tonal sculpture for the executive suite at the Sentry Insurance headquarters in Stevens Point, Wisconsin, recalled of his experience working with the "gracious" artist:

> He was happy to provide an idea
> for the Sentry HQ and once made
> in Pennsylvania, he shipped it
> to Stevens Point in three wood
> crates. He came to install it in

the executive suite. The three shipping crates were about 10 feet in length. Harry went about the installation in his usual informal style and when one of the rods had gotten bent during shipping, he bent the rod to the floor and it returned to perfectly align with all the other vertical rods. ... The end result was a shimmering sculpture resembling tall grass or wheat that seemed a perfect focal point for the space.[17]

Much of this correspondence conveys sincere mutual respect and enthusiastic exchange between artist and architect. In numerous cases, Bertoia suggested solutions to architectural problems, and architects proffered changes that might better serve his sculpture. For example, in a letter from John M. Garber regarding their collaboration on St. John's Unitarian Church in Cincinnati, Ohio, the architect informed Bertoia that the building would be far enough along in a couple of months, "so that a visit from you would be useful," but also noted that he was reconsidering the placement and form of the commissioned sculpture:

> *As the building progresses it seems to me that perhaps the "Flame" should be inside behind the altar rather than outside. As the building now stands, it seems to me that even a rather large version of the rod type sculpture which you are now working on might be too delicate in combination with the exposed steel work. In any case it would be very valuable if we could go over the project at the site.*[18]

Bertoia was particularly sensitive to the specifics of the site when working on a commission and willing to make changes to his work based on the input of the client, but just as often architects were open to modifying their design to best accommodate his sculpture. For example, in the case of his second major commission, a sculpture for the Manufacturers Trust Bank (see Appendix) at 510 Fifth Avenue in New York designed by Skidmore, Owings & Merrill, Bertoia spoke highly of the openness and trust bestowed upon him by the supervising architect on the project, Gordon Bunshaft. Like Saarinen, who was good friends with both men, Bunshaft personally selected Bertoia after seeing his work at the Knoll Showroom.[19] Bertoia recalled of the project:

> *Gordon Bunshaft called me up, he said we're going to do a bank but before we start, I'd like you to come up with something, you know a really big sculpture. Well I said how big? Oh, it's about 20 feet high, 70 feet long ... good heavens, I dropped the phone. ... He was very diplomatic. He said once you come up with something, then we'll build a building around it.*[20]

The resulting sculpture (fig. 8), installed on the second floor, bears some formal similarities to Bertoia's screen for the General Motors Technical Center but is larger and far more complex. The seven major sections of brazed and welded metal took him eight months to complete, from November 1953 to the late July 1954. Welded enameling steel is the core material of the work, but Bertoia treated the surface of the 800 plates and connecting elements with an innovative combination of liquid brass, copper, and nickel. The seemingly even, shimmering surface of the screen explodes in areas where the mixture of melted, oozing metals have hardened into built-up pools or conversely eroded away into pockmarks, exposing a multiplicity of layers below.[21]

Bertoia's ability to experiment with a

Fig. 8
Harry Bertoia, *Untitled (Multi-Plane Construction)*, 1954,
Manufacturers Trust Company, 510 Fifth Avenue, New York, NY.
Architect: Skidmore, Owings & Merrill (Gordon Bunshaft).

new technique on such a prominent project is a testament again to the trust placed by his clients in his abilities, but it also reflected the overall innovation and architectural ambition of the building the sculpture occupied. Bunshaft took the sculpture into consideration during the design phase, and Bertoia in return mirrored the transparency and geometry of the building, the rectangularity of the sculpture's structure and panels reflecting the lines of the ceiling as well as the overall metal and glass framework (see p. 193). The overall effect of the screen, both then and now, is a particular combination of visual lightness and tangible, metallic materiality; its roughly sculpted, radiant gold surface, catching and reflecting light, reveals the diversity of elements punctuating its gridded structure.

Contemporary criticism repeatedly remarked on the successful collaboration between artist and architect at Manufacturers Trust, with many noting how well the sculpture synergized with the whole of the building, to the point where "one could not exist successfully without the other."[22] *Arts & Architecture* declared, for example, that SOM's Manufacturers Trust building "represents not only a fresh point of view in banking architecture but is an excellent example of what happens when the architect works intelligently and cooperatively with the artist."[23] Bertoia was awarded the Gold Medal in Design and Craftsmanship from the Architectural League in 1955 for the project. For his part, Bunshaft would state years after the completion of the Manufacturers Trust building that Bertoia "did a good job," which for a man of notoriously few words but many strong opinions was high praise indeed.[24]

Bertoia's large-scale commissions, however, were not simply built around the relationship between artist and architect or artist and client, but also took into account that they were being made to exist in the world, to be accessible to many, even if their creation was enabled by a select few.

Bertoia's attention to the specifics of site and the care he took in creating each commission were not simply about how well his sculpture would complement the architectural design, but also how viewers would encounter these objects in real, lived space. As Bertoia stated in 1972:

> It is my meaning that art should belong to everyday life. It should be incorporated in the society where it can be seen by everyone, where it can encourage a more open attitude toward art. By this, one could reduce the distance between today's art and the public. I am interested in my fellow being, in what they say about me and what I can tell them. The moment of sharing is equal to the moment of creation.[25]

A large majority of the large-scale commissions still reside in the places for which they were conceived. They continue testifying to the rich historical contexts of their creation, of cross-disciplinary collaboration and material connection. Perhaps more importantly, they also continue to engender profound moments of sharing, if one only takes the time to listen.

1 Robert Judson Clark and Andrea P. A. Belloli, *Design in America: The Cranbrook Vision, 1925–1950* (New York: Abrams, 1983).

2 Katherine and Michael McCoy, "Academy Designers Influence the Look of Twentieth-Century America," *Cranbrook Quarterly* 7, no. 2 (November 1981), 4.

3 Wolf Von Eckardt, "Our Bauhaus," *Time* 123, no. 19 (May 7, 1984), 92.

4 Paul Cummings, oral history interview with Harry Bertoia, June 20, 1972, the Archives of American Art, Smithsonian Institution, Tape 2, Side 1; transcript, 5.

5 Virginia Lee Warren, "Woman Who Led an Office Revolution Rules an Empire of Modern Design," *New York Times* (September 1, 1964), 40.

6 For a history of Knoll, see Kathryn Bloom Hiesinger and Bobbye Tigerman, *Florence Knoll Bassett: Defining Modern* (Philadelphia: Philadelphia Museum of Art, 2004); Brian Lutz, *Knoll: A Modernist Universe* (New York: Rizzoli, 2010).

7 Olga Guelft, "Bertoia: his sculpture, his kind of wire chair," *Interiors* 112 (October 1952), 119.

8 Mark Coir, "The Cranbrook Factor," in *Eero Saarinen: Shaping the Future*, eds. Eeva-Liisa Pelkonen and Donald Albrecht (New Haven: Yale University Press, 2006), 41.

9 Oral-history interview with Harry Bertoia, 18–19.

10 For more on the relationship between American sculpture and architecture at midcentury, see Marin R. Sullivan, "Synergizing Space: Sculpture, Architecture, and Richard Lippold at Lincoln Center," *American Art* 33, no. 2 (Summer 2019), 38–61.

11 Herbert Hannum, "Collaboration," *Craft Horizons* (May–June 1956), 11.

12 "A School with Scale," *Architectural Forum* 103, no. 2 (August 1955), 124–29; Minoru Yamasaki Papers, Box 12, Wayne State University; and Minoru Yamasaki, *A Life in Architecture* (Tokyo: Weatherhill, 1979), 192.

13 Anne McIlhenny Matthews, "Bertoia, Yamasaki Honored," *Courier Express* (Buffalo), August 22, 1968.

14 Vincent Scully, *American Architecture and Urbanism* (New York: Praeger, 1969), 193. For more on the "second generation," see for example Alice T. Friedman, *American Glamour and the Evolution of Modern Architecture* (New Haven: Yale University Press, 2010); Dale Allen Gyure, *Minoru Yamasaki: Humanist Architecture for a Modernist World* (New Haven: Yale University Press, 2017); Ada Louise Huxtable, "Pools, Dome, Yamasaki –Debate," *New York Times Magazine* (November 25, 1962), 36–37, 158; and Jeffrey Lieber, *Flintstone Modernism: Or The Cultural Crisis in Postwar American Culture* (Cambridge, MA: The MIT Press, 2018).

15 Letter from Minoru Yamasaki to Mr. Charles W. Millard, Jr., February 2, 1967, Harry Bertoia Papers, 1917–1979, Archives of American Art, Smithsonian Institution (hereafter Bertoia Papers).

16 Letter from Edward Durell Stone to Harry Bertoia, April 12, 1974, Edward Durell Stone Papers, 1927–1974, University of Arkansas.

17 Bennett Johnson, email correspondence with the author, November 7, 2018.

18 Letter from John M. Garber to Harry Bertoia, February 29, 1960, Bertoia Papers.

19 Nicholas Adams, "Gordon Bunshaft: What Convinces Is Conviction," *SOM Journal* 9 (January 31, 2013). Also available via SOM's website, http://www.som.com/news/gordon_bunshaft_what_convinces_is_conviction

20 Oral-history interview with Harry Bertoia, 20.

21 For a more detailed analysis of this commission, see Marin R. Sullivan, "Alloyed Screens: Harry Bertoia and the Manufacturers Hanover Trust Building – 510 Fifth Avenue," *Sculpture Journal* 25, no. 3 (2016), 361–80.

22 "Metal Sculpture – Harry Bertoia," *Arts & Architecture* 72, no. 1 (January 1955), 18.

23 Ibid.

24 "Oral History of Gordon Bunshaft," interviewed by Betty J. Blum, 1990, compiled under the auspices of the Chicago Architects Oral History Project, Department of Architecture, Art Institute of Chicago, http://digital-libraries.saic.edu/cdm/ref/collection/caohp/id/18407

25 Harry Bertoia quoted in Ingebjørg Nesheim, "The World of Bertoia," *Frisprog* (November 18, 1972). Transcript sent to Bertoia by Galleri KB (Kaare Bernsten), February 16, 1973, Bertoia Shop Files 14015, Harry Bertoia Foundation.

Introduction to the Plates

A Few Notes on Categorization

Harry Bertoia created thousands, perhaps tens of thousands, of distinct designs, graphics, and sculptures over the course of his nearly forty-year career. With only a few exceptions, none of these pieces were signed, dated, or titled by the artist. He also used a myriad of materials and techniques, many of which were unique to his artistic practice. While there are distinctive styles or approaches associated with various periods of his career, Bertoia did not work in strict series, often returning to or building upon earlier experiments and realized pieces. He also frequently switched between mediums, often in a single day, working on a sculpture in his Bally, PA studio during the day and creating monotypes in his barn studio in nearby Barto late into the evening.

The realities of Bertoia's diverse and prolific career result in particular challenges to researchers, curators, and collectors, particularly in how to identify or label works individually and how to categorize them collectively. In 2019, the Harry Bertoia Foundation launched a comprehensive Catalogue Raisonné project, a multi-year undertaking that will result in a digital publication, released in stages, and continually updated. Beyond the arduous goal of researching and documenting as many works as possible, a crucial component of the project has been to better define and unify the language specific to Bertoia's artistic output.

In regard to identification, over the forty-plus years since Bertoia's death a number of consistent, if ultimately incorrect, titling conventions have been applied to his work. First and foremost, Bertoia rarely titled his work, the exceptions often taking place surrounding commissioned projects, when the patron insisted upon a title or a work acquired a referential one through popular usage. Almost all works should be listed as *Untitled* though certain descriptive labels have become common as titles. As June Kompass Nelson wrote during Bertoia's lifetime, "Aesthetic ideas and intellectual concepts have led him to create abstract forms which were later identified with such things in nature as bushes, trees, flowers, dandelions, dogwood, sunbursts, galaxies, reeds, and straw. But it should be noted that the names were applied largely as a convenient reference." While "willow" or "spill cast," for example, are helpful descriptors designating a particular form or technique, such terms are neither correct titles nor benign placeholders devoid of specific meaning.

Focusing on the exceptional materials, techniques, and processes used or created by Bertoia has proven the best, most authentic guide to categorizing his work posthumously. Welding, for example, became a central core process within Bertoia's work but spill cast, fused shot, and melt press each designate specific ways he transformed bronze. Bertoia also used wire, for instance, across his sculptural output, but his so-called "gathered wire" works, including the willows and sprays, are distinct from other wire forms like the dandelions, open form constructions, or straws.

One area that has been particularly susceptible to mislabeling has been Bertoia's sounding sculpture, a category comprised of gongs, singing bars, and tonals—sculptures made of rods in varying heights, metals, configurations, sometimes topped with a bud, cylinder, or cattail top. Sonambient, a neologism invented by Bertoia, is often used as a shorthand or synonym for sounding sculpture and frequently appears as a modifier for Bertoia's barn studio (i.e. the Sonambient Barn) or works that were, at one time, placed and played inside the barn. The term, however, should only be used to designate the recordings Bertoia made in the 1970s, which have subsequently been released as LPs, CDs, and digital files; in reference to the film made by Jeffrey and Miriam Eger in 1971; or as an artistic concept connoting the use of sculpture to create an ambient sound environment, often associated with performances enacted by Bertoia in his Barto barn.

While the ongoing Harry Bertoia Catalogue Raisonné continues to refine and coalesce the terminology applied to the artist's work, this exhibition—while being attentive to these efforts and the developing Bertoia lexicon—was shaped by the guiding principle that Bertoia's creative output shares a singular, holistic language. As such, the plates in this catalogue are organized as chronologically as possible, both to avoid the division of his practice into silos like design, graphics, and sculpture, and to demonstrate the depth and complexity of his fluid movement across materials, mediums, and techniques.

Marin R. Sullivan
Director, Harry Bertoia Catalogue Raisonné

Tea Service, 1938–39
Silver and acrylic

Teapot: 5 5/8 × 4 1/8 × 7 1/4 in. (14.3 × 10.5 × 18.4 cm); sugar bowl with cover:
3 1/4 × 4 1/4 × 2 7/8 in. (8.3 × 10.8 × 7.3 cm); creamer: 2 1/2 × 2 7/8 × 4 3/4 in.
(6.4 × 7.3 × 12.1 cm); tray: 3/4 × 12 3/4 × 8 7/8 in. (1.9 × 32.4 × 22.5 cm)
Detroit Institute of Arts, Bequest of Mrs. George Kamperman

cat. 2

Vase, c. 1940
Spun bronze

Height: 11 1/4 in. (28.6 cm), diameter at top: 5 9/16 in. (14.1 cm)
Cranbrook Art Museum, Transfer from Cranbrook House, George Gough Booth
and Ellen Scripps Booth Collection (CAM 1980.2)

cat. 3
Bracelet, c. 1940s
Brass

2 × 2 3/8 × 2 1/2 in. (5.1 × 6 × 6.4 cm)
Harry Bertoia Foundation

cat. 4
Brooch, c. 1940s
Silver
7/8 × 3 1/4 × 1/2 in. (2.2 × 8.3 × 1.3 cm)
Harry Bertoia Foundation

cat. 5
Pendant, 1942
Forged silver, woven silver wire, and ebony

4 1/2 × 5 1/2 × 5/8 in. (11.4 × 14 × 1.6 cm)
Courtesy Lost City Arts, New York

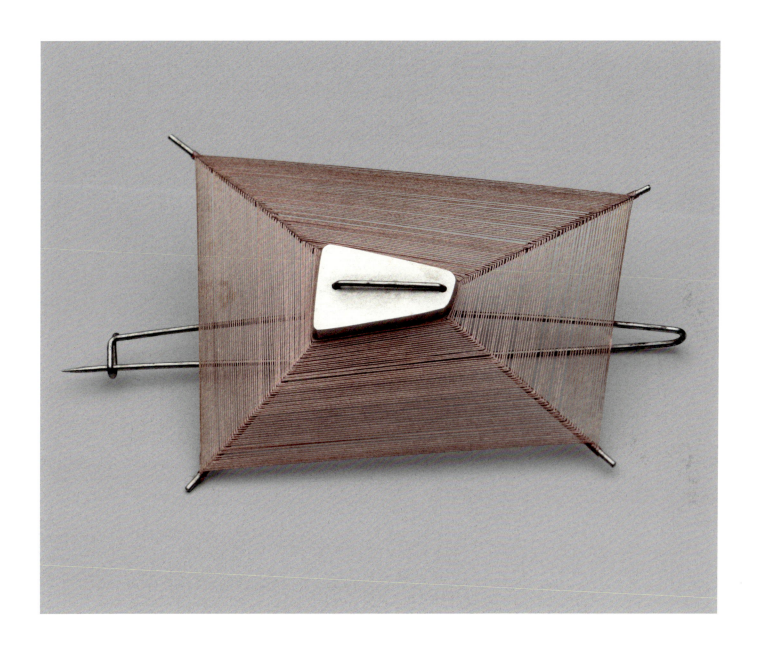

cat. 6
Brooch, c. 1939–43
Aluminum, thread, and steel

2 1/8 × 3 1/2 × 5/8 in. (5.4 × 8.9 × 1.6 cm)
Dallas Museum of Art, Gift of Deedie Rose (2010.35)

cat. 7
Ornamental Centipede, c. 1942
Hammered brass

19 3/4 × 8 × 1/2 in. (50.2 × 20.3 × 1.3 cm)
Cranbrook Art Museum, Gift of George Gough Booth and Ellen Scripps
Booth through the Cranbrook Foundation (CAM 1943.12)

cat. 8
Dress Ornaments, c. 1943
Brass

5 1/4 × 2 3/4 × 1/2 in. (13.3 × 7 × 1.3 cm) each
Cranbrook Art Museum, Gift of Robert Saarinen Swanson
and Ronald Saarinen Swanson (CAM 1990.85.B)

cat. 9
***Necklace,* c. 1943**
Forged and fabricated gold

Chain: 9 in. (22.9 cm)
Pendants: 1 3/4 × 1 1/8 × 1/16 in. (4.4 × 2.9 × 0.2 cm) each
Collection of Kim and Al Eiber

cat. 10
***Brooch*, c. 1943**
Welded silver with applied patina and riveted coral and ebony

1 3/4 × 3 1/4 × 1/2 in. (4.4 × 8.3 × 1.3 cm)
Courtesy Lost City Arts, New York

cat. 11
Untitled, **c. 1942**
Monotype

8 × 6 1/2 in. (20.3 × 16.5 cm)
Solomon R. Guggenheim Museum, New York.
Solomon R. Guggenheim Founding Collection, 43.912.68

cat. 12
Untitled, c. 1943
Monotype

8 × 6 1/2 in. (20.3 × 16.5 cm)
Solomon R. Guggenheim Museum, New York.
Solomon R. Guggenheim Founding Collection, 43.912.69

cat. 13
Untitled, c. 1943
Monotype

6 1/2 × 8 in. (16.5 × 20.3 cm)
Solomon R. Guggenheim Museum, New York.
Solomon R. Guggenheim Founding Collection, 43.912.74

cat. 14

Untitled, c. 1943
Monotype, ink on Japanese paper

10 1/16 × 10 1/16 in. (25.6 × 25.6 cm)
Harry Bertoia Foundation

cat. 15
***Untitled,* n.d.**
Monotype, ink on Japanese paper

16 1/8 × 22 3/16 in. (41 × 56.4 cm)
Harry Bertoia Foundation

774

cat. 16
Untitled, c. 1940s
Monotype on wove paper

25 × 38 in. (63.5 × 96.5 cm)
Allentown Art Museum, Purchase: SOTA
Print Fund, 1992 (1992.05.10)

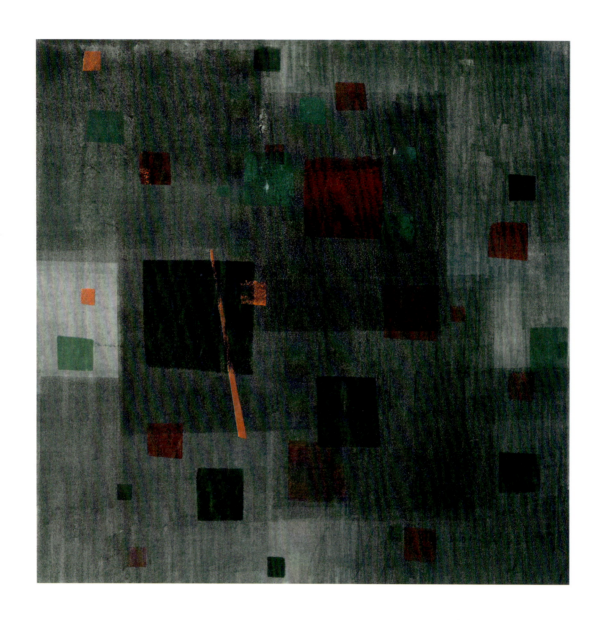

cat. 17

Untitled Monotype (Non-Objective Polychrome Block Print), c. 1943
Ink on oriental laid paper

14 × 14 in. (35.6 × 35.6 cm)
Cranbrook Art Museum, Gift of George Gough Booth and Ellen Scripps Booth (CAM 1943.4)

cat. 18

***Untitled Monotype (Non-Objective Polychrome Block Print),* c. 1943**
Ink on Japanese style paper

39 7/8 × 24 3/4 × 1 1/2 in. (101.3 × 62.9 × 3.8 cm) [framed]
Cranbrook Art Museum, Gift of Dr. and Mrs. Irving F. Burton (CAM 1981.42)

cat. 19
Untitled Monotype (Non-Objective Polychrome Block Print)
***from the Synchromy Series,* c. 1943**
Ink on an oriental laid paper

Image: 16 1/4 × 13 in. (41.3 × 33 cm)
Cranbrook Art Museum, Gift of the Artist (CAM 1943.81)

Composition in Grey, c. 1945
**Monotype and transfer drawing in black ink with
touches of opaque white on cream Japanese paper**

10 3/8 × 7 3/4 in. (26.3 × 19.6 cm)
The Art Institute of Chicago, Gift of the Print and Drawing Club, 1946.260

cat. 21
Composition in Green and Brown, c. 1945
Color monotype and transfer drawing on ivory Japanese paper

7 3/4 × 5 1/2 in. (19.6 × 13.9 cm)
The Art Institute of Chicago, Gift of the Print and Drawing Club, 1946.261

cat. 22
Monoprint No. 14, **before 1945**
Monotype on paper

11 × 9 1/2 in. (27.9 × 24.1 cm)
The Phillips Collection, Washington, D.C. Acquired 1945

cat. 23
***Untitled,* 1946**
Monotype on laid rice paper

28 × 39 3/4 in. (71.1 × 101 cm)
Allentown Art Museum, Purchase: SOTA Print Fund,
1992 (1992.05.1)

cat. 24
Brooch, c. 1945
Forged and riveted silver with ebony elements
4 1/4 × 1 7/8 × 3/4 in. (10.8 × 4.8 × 1.9 cm)
Collection of Kim and Al Eiber

cat. 25
Brooch, c. 1947
Forged and riveted silver electroplated with gold
3 1/2 × 4 × 3/8 in. (8.9 × 10.2 × 1 cm)
Philadelphia Museum of Art, Gift of Frances Elliot Storey and Gay Elliot Scott, 2014

cat. 26
***Brooch*, c. 1947**
Forged and riveted silver electroplated with gold
3 × 3 1/2 × 3/8 in. (7.6 × 8.9 × 1 cm)
Philadelphia Museum of Art, Gift of Frances Elliot Storey and Gay Elliot Scott, 2014

789

Untitled, n.d.
Monotype, ink on Japanese paper

7 9/16 × 9 3/16 in. (19.2 × 23.3 cm)
Harry Bertoia Foundation

790

cat. 28
Untitled, n.d.
Monotype, ink on Japanese paper

7 3/8 × 7 3/8 in. (18.7 × 18.7 cm)
Harry Bertoia Foundation

cat. 29

Brooch, c. 1947
Forged and cold connected sterling silver

4 5/8 × 2 7/8 × 1/8 in. (11.7 × 7.3 × 0.3 cm)
Collection of Kim and Al Eiber

cat. 30
Brooch, c. 1949
Forged and riveted silver
5 × 3 1/4 × 1/4 in. (12.7 × 8.3 × 0.6 cm)
Collection of Kim and Al Eiber

cat. 31

Pendant, c. 1950
Silver with ebony and coral

5 1/2 × 3 × 1/4 in. (14 × 7.6 × 0.6 cm)
Courtesy Lost City Arts, New York

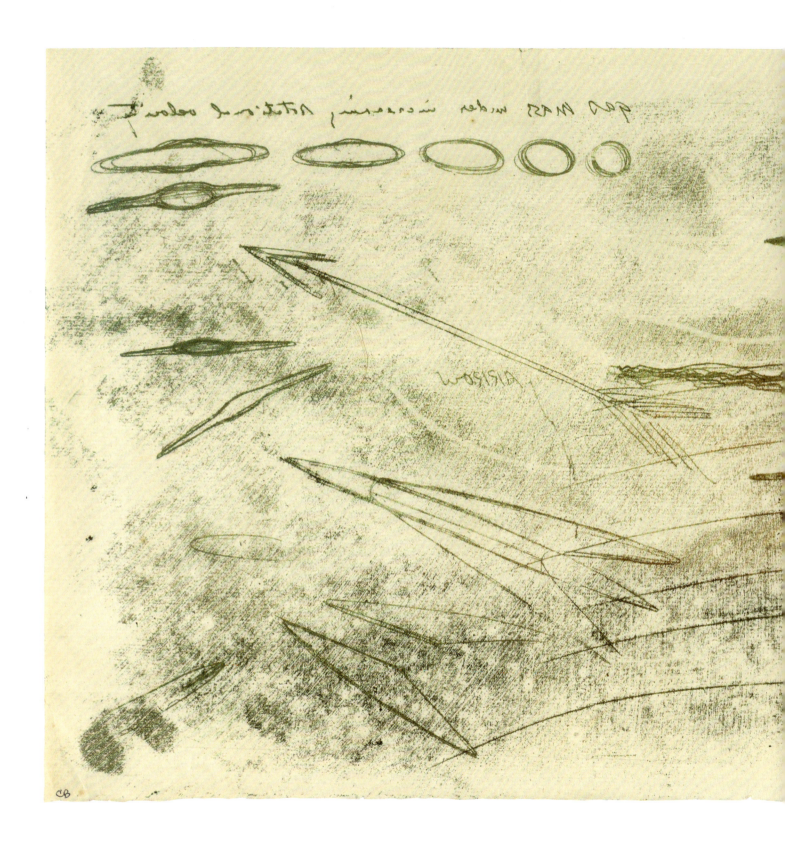

cat. 32
***Untitled* (70A), c. 1940s**
Monotype, ink on Japanese paper

10 3/4 × 21 3/4 in. (27.3 × 55.2 cm)
Harry Bertoia Foundation

70a

cat. 33

***Untitled,* n.d.**
Monotype, ink on Japanese paper

10 1/4 × 26 1/2 in. (26 × 67.3 cm)
Harry Bertoia Foundation

cat. 34
Abstraction, before 1952
Monotype on paper

14 7/16 × 20 in. (36.7 × 50.8 cm)
Collection of the University of Michigan Museum of Art, Ann Arbor, Michigan;
Gift of Mr. Robert H. Tannahill, 1952/1.85

cat. 35
Landscape Fantasy, c. 1950
Lead, wire, and stone slab

16 × 28 1/2 × 12 1/2 in. (40.6 × 72.4 × 31.8 cm)
Collection Museum of Contemporary Art Chicago,
Gift of Ruth Horwich, 1993.5.a-j

cat. 36
***Prototype "Diamond" Chair,* c. 1952**
Enameled steel

23 1/4 × 34 1/2 × 30 in. (59 × 87.6 × 76 cm)
Collection of Julie & David Eskenazi, Courtesy of R & Company

"Bird" Lounge Chair, designed 1952, manufactured c. 1970–80
Steel and upholstery

38 1/2 × 38 × 34 in. (97.9 × 96.5 × 86.4 cm)
Dallas Museum of Art, Gift of Knoll International (1990.132)

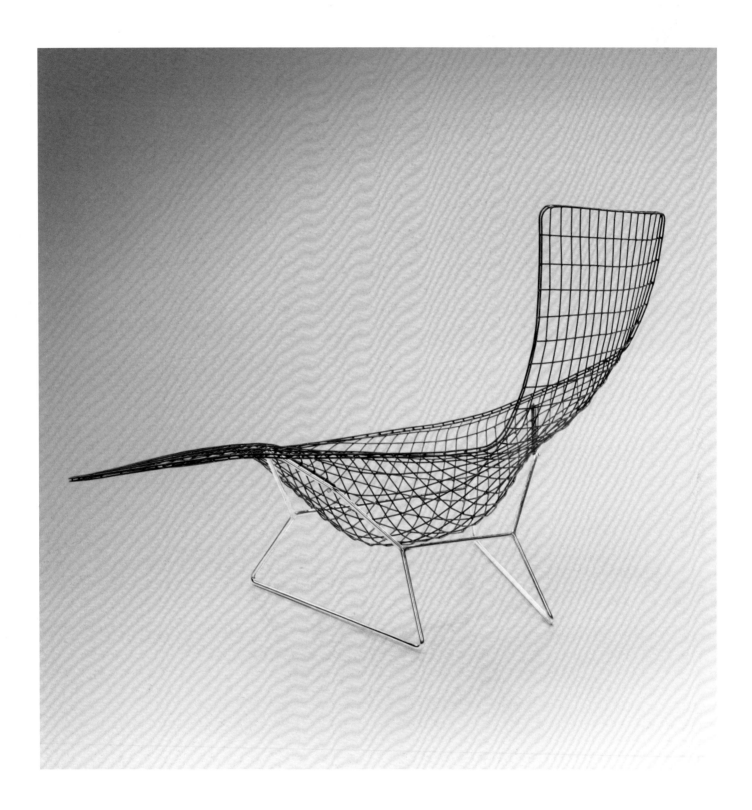

cat. 38
***Hand Made Chair Prototype (Asymmetric Chaise Lounge),* c. 1952**
Bronze braised steel rods on chrome-plated steel base

37 × 53 × 32 1/2 in. (94 × 134.6 × 82.6 cm)
Collection of Wilbur and Joan Springer

cat. 39
Maquette for Conceptual Sculpture, c. 1953
Brass welded coating on steel wire

18 × 19 1/8 × 9 5/8 in. (45.7 × 48.6 × 24.5 cm)
Davis Museum at Wellesley College, Wellesley, Massachusetts,
Gift of Jacqueline Loewe Fowler (Class of 1947)

cat. 40
Untitled, 1953
Steel base with brass melt coating
17 3/4 × 29 1/2 × 4 in. (45.2 × 74.9 × 10.2 cm)
Harry Bertoia Foundation

cat. 41
Untitled, c. 1968
Brass-coated steel

33 × 7 1/4 × 10 in. (83.8 × 18.4 × 25.4 cm)
Collection of halley k harrisburg and Michael Rosenfeld, New York

cat. 42
***Untitled,* 1953**
Bronze-coated iron

33 × 17 × 10 in. (83.82 × 43.18 × 25.4 cm)
Collection Albright-Knox Art Gallery, Buffalo, New York,
Gift of Mr. and Mrs. Gordon Bunshaft, 1964

Sculpture, c. early 1950s
Welded metal, brazed

26 × 17 1/2 × 11 in. (66 × 44.5 × 27.9 cm)
North Carolina Museum of Art, Raleigh, Bequest of W. R. Valentiner

cat. 44

***Construction after the Enjoyment of a Mulberry Tree,* 1953**
Steel, bronze, and silver

45 × 53 1/2 × 9 in. (114.3 × 135.9 × 22.9 cm)
The Art Institute of Chicago, Watson F. Blair Prize Fund, 1954.272

12

cat. 45
Untitled, n.d.
Monotype, ink on paper
21 × 29 5/8 in. (53.3 × 75.2 cm)
Harry Bertoia Foundation

cat. 46

Untitled (Multi-Plane Construction), c. 1953
Gilded copper and bronze

122 1/2 × 36 × 36 in. (311.2 × 91.4 × 61 cm)
The Museum of Fine Arts, Houston, Museum purchase funded
by the John R. Eckel, Jr. Foundation, 2011.412

cat. 47–53

Untitled, 1954
Monotypes on laid rice paper

5 5/8 × 23 5/8 in. (14.3 × 60 cm) each
Allentown Art Museum, Gift of Brigitta Bertoia, 1982

cat. 54
***Untitled,* 1950s**
Patinated bronze

5 3/4 × 8 × 8 in. (14.6 × 20.3 × 20.3 cm)
Harry Bertoia Foundation

cat. 55

Untitled, c. 1954–55
Welded metal

28 1/4 × 10 5/8 × 4 in. (71.8 × 27 × 10.2 cm)
Solomon R. Guggenheim Museum, New York,
Gift, William C. Edwards, Jr. in memory of Sibyl H. Edwards, 1980

cat. 56

Screen Tree, c. 1955
Brass coated wire

57 3/4 × 84 × 11 in. (146.7 × 213.4 × 27.9 cm)
Crystal Bridges Museum of American Art, Bentonville, Arkansas, 2012.500

cat. 57

Hanging Sculpture, c. 1956
Bronze

48 1/2 × 18 × 9 1/2 in. (123.19 × 45.72 × 24.13 cm)
Virginia Museum of Fine Arts, Richmond, Gift of the Friends
of Taylor Simmons as a Memorial to Him (58.34)

cat. 58
***Tree,* c. early 1950s**
Welded metal, brazed

14 × 10 1/2 × 6 1/4 in. (35.6 × 26.7 × 15.9 cm)
North Carolina Museum of Art, Raleigh, Bequest of W. R. Valentiner

cat. 59
Tree, **1957**
Brass, copper and steel

92 × 78 × 46 in. (235.5 × 198 × 116.8 cm)
Virginia Museum of Fine Arts, Richmond, Gift of an Anonymous Donor (58.51)

cat. 60
***Untitled (Cloud)*, c. 1957**
Melt-coated bronze over steel

5 1/2 × 17 × 43 in. (14.0 × 43.2 × 109.2 cm)
Courtesy of Michael Rosenfeld Gallery, New York, NY

cat. 61
***Untitled*, c. 1958**
Bronze

53 × 98 × 12 in. (134.62 × 248.92 × 30.48 cm)
Collection of the University of Michigan Museum of Art, Ann Arbor, Michigan;
Gift of the Lannan Foundation in honor of the Pelham Family, 1997/1.117

cat. 62
Untitled (Wall Sculpture), 1958
Bronze

41 3/4 × 63 × 9 1/4 in. (106 × 160 × 23.5 cm)
Cranbrook Art Museum, Gift of Peggy and Stanley Winkleman (CAM 194.34)

cat. 63

***Sculpture Group Symbolizing
World's Communication in the
Atomic Age,* 1959
Brazed and welded brass; bronze**

142 1/4 × 231 1/4 × 81 in.
(361.4 × 587.4 × 205.8 cm)
Smithsonian American Art Museum,
Gift of the Zenith Corporation

cat. 64
Untitled, c. 1960
Brazed steel wire and rod

53 × 88 7/8 × 22 in. (134.6 × 225.7 × 55.9 cm)
Whitney Museum of American Art, New York. Gift of Dr. and Mrs. Sheldon C. Sommers, 86.53

cat. 65
Untitled (Cloud), c. 1962
Brass coated steel

14 1/2 × 33 × 22 1/4 in. (36.8 × 83.8 × 56.5 cm)
Courtesy of Michael Rosenfeld Gallery, New York, NY

cat. 66
Untitled, n.d.
Monotype, ink on Japanese paper

24 1/16 × 13 in. (61.1 × 33 cm)
Harry Bertoia Foundation

cat. 67
Untitled, n.d.
Monotype, ink on Japanese paper

13 1/2 × 24 in. (34.3 × 61 cm)
Harry Bertoia Foundation

cat. 68
Untitled (Sunburst), 1960
Polished bronze wire and rod

76 × 32 × 32 in. (193 × 81.3 × 81.3 cm)
Nancy A. Nasher and David J. Haemisegger Collection

cat. 69
***Untitled (Dandelion),* 1960s**
Gilded stainless steel

74 × 34 × 34 in. (188 × 86.4 × 86.4 cm)
Collection of Dr. Charles B. Key

cat. 70
***Dogwood VII*, 1962**
Bronze

25 1/2 × 17 × 17 in. (64.8 × 43.2 × 43.2 cm)
Collection Walker Art Center, Minneapolis. Gift of Judy and Kenneth Dayton, 1999

Untitled (Tree), c. 1962
Welded copper and bronze with applied patina

42 × 24 1/2 × 26 1/2 in. (106.7 × 62.2 × 67.3 cm)
Courtesy of Michael Rosenfeld Gallery, New York, NY

cat. 72
Untitled, c. 1964
Bronze welded wire with patina

10 × 15 × 16 in. (25.4 × 38.1 × 40.6 cm)
Harry Bertoia Foundation

cat. 73
Untitled, n.d.
Pen, ink, and marker on paper

17 5/8 × 22 1/2 in. (44.8 × 57.2 cm)
Harry Bertoia Foundation

sketches 1060

cat. 74
Untitled, n.d.
Monotype, ink on Japanese paper
24 1/16 × 39 1/4 in. (61.1 × 99.7 cm)
Harry Bertoia Foundation

cat. 75
Untitled (Sphere Sculpture), c. 1965
Bronze

8 × 8 1/2 in. (20.3 × 21.6 cm)
Harry Bertoia Foundation

Flowering, 1965
Bronze

35 × 18 in. (88.9 × 45.72 cm)
Milwaukee Art Museum, Gift of Mrs. Harry Lynde Bradley, M1975.132

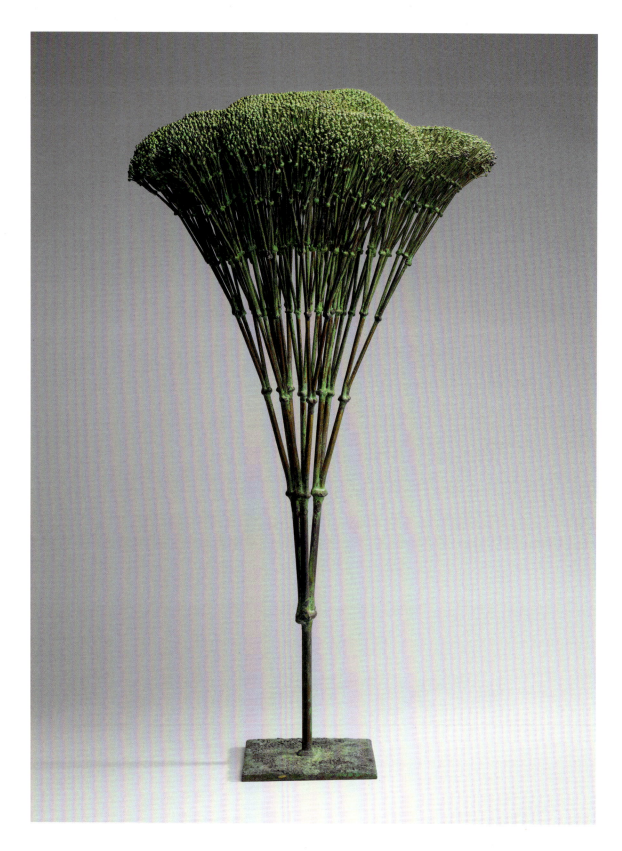

cat. 77
Tree Form (Broccoli), c. 1965
Patinated bronze

40 × 23 1/2 × 21 1/2 in. (101.6 × 59.7 × 54.6 cm)
The Museum of Fine Arts, Houston, Museum purchase funded
by the John R. Eckel, Jr. Foundation, 2011.417

cat. 78

***Untitled,* 1965**
**Stainless steel wires set in artist's concrete
base with aluminum trim**

48 5/8 × 13 × 13 in. (123.4 × 33 × 33 cm)

Hirshhorn Museum and Sculpture Garden, Smithsonian Institution,
Washington, D.C., Gift of Joseph H. Hirshhorn, 1966

Untitled (Willow), c. 1965
Stainless steel

84 × 48 × 48 in. (213.4 × 121.9 × 121.9 cm)
Harry Bertoia Foundation

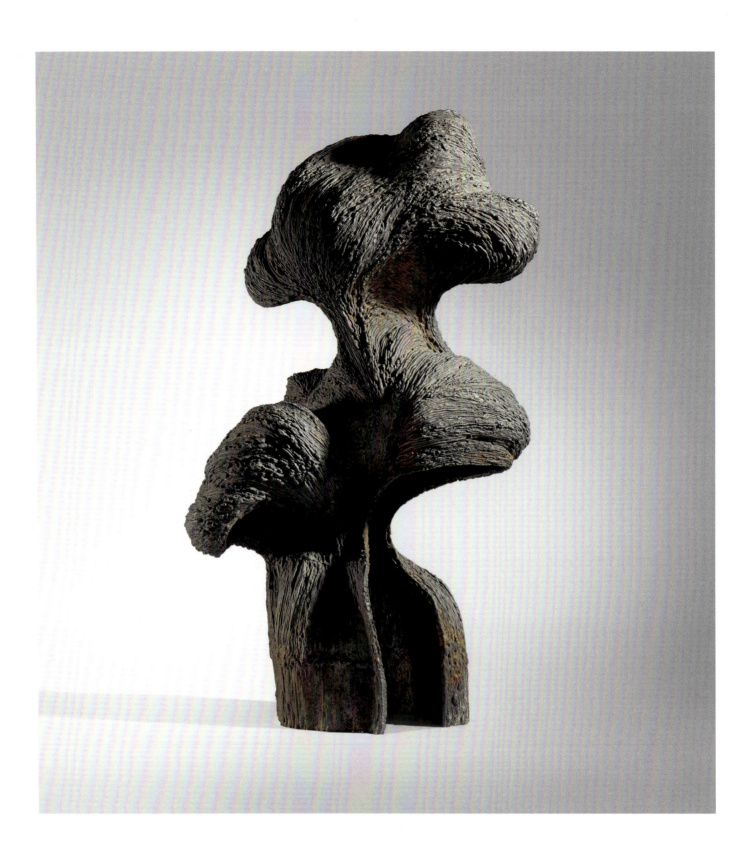

cat. 80
Untitled (Welded Form), c. 1965
Welded bronze

24 1/8 × 11 3/8 × 14 3/4 in. (61.3 × 28.9 × 37.5 cm)
Private collection

cat. 81
***Bush,* 1967**
Bronze, green patina

68 × 35 × 35 in. (172.7 × 88.9 × 88.9 cm)
Brooklyn Museum, Gift of The Beatrice and Samuel A. Seaver Foundation, 2004.30.3a-b

cat. 82
***Untitled,* n.d.**
Monotype, ink on Japanese paper
19 11/16 × 12 1/8 in. (50 × 30.8 cm)
Harry Bertoia Foundation

cat. 83
Untitled, n.d.
Monotype, ink on Japanese paper
12 1/2 × 25 5/16 in. (31.8 × 64.3 cm)
Harry Bertoia Foundation

cat. 84
Untitled, n.d.
Monotype, ink on Japanese paper

12 1/2 × 25 5/16 in. (31.8 × 64.3 cm)
Harry Bertoia Foundation

cat. 85
Untitled, n.d.
Monotype, ink on Japanese paper

12 5/8 × 25 5/16 in. (32.1 × 64.3 cm)
Harry Bertoia Foundation

cat. 86

***Untitled,* c. 1960s**
Monotype on laid rice paper

24 × 39 1/2 in. (61 × 100.3 cm)
Allentown Art Museum, Purchase, SOTA Print Fund, 1992

cat. 87
Untitled (Cube), c. 1968
Welded bronze wire

14 × 12 × 13 1/2 in. (35.6 × 30.5 × 34.3 cm)
Harry Bertoia Foundation

cat. 88
***Untitled (Spill Cast)*, c. 1960**
Bronze with patina

25 1/2 × 51 × 6 1/2 in. (64.8 × 129.5 × 16.5 cm)
Courtesy of Michael Rosenfeld Gallery, New York, NY

cat. 89
Untitled (Spill Cast), 1960s
Bronze

15 × 55 in. (38.1 × 139.7 cm)
Harry Bertoia Foundation

cat. 90
Untitled, c. 1966
Bronze

22 × 39 1/4 × 7 3/4 in. (55.9 × 99.7 × 19.7 cm)
Collection of the Flint Institute of Arts, Flint, Michigan,
Gift of Mr. and Mrs. David Martin, 1967.27

cat. 91
Willow, c. 1968
Steel

52 3/4 × 43 in. (134 × 109.2 cm)
The Museum of Fine Arts, Houston, Museum purchase funded
by the John R. Eckel, Jr. Foundation, 2011.423.A-C

cat. 92

Double Hanging Willow
(from the Seattle First National Bank), 1968
Stainless steel

110 in. (279.4 cm) tall
Rago-Wright Auctions and Lost City Arts, Courtesy of R & Company, New York

cat. 93
Untitled, **c. 1970**
Fused bronze shot

17 1/4 × 18 × 13 in. (43.8 × 45.7 × 33 cm)
Collection of Dr. Charles B. Key

Bush Form, c. 1970
Gilded bronze

10 1/8 × 13 1/4 in. (25.7 × 33.7 cm)
The Museum of Fine Arts, Houston, Museum purchase
funded by the John R. Eckel, Jr. Foundation, 2011.418

Untitled, c. 1970
Beryllium copper rods on brass base

25 × 14 1/16 × 6 in. (63.5 × 35.7 × 15.2 cm)
Harry Bertoia Foundation

cat. 96
***Untitled,* 1970s**
Beryllium copper rods on brass base

83 × 11 7/8 × 11 7/8 in. (210.8 × 30.2 × 30.2 cm)
Harry Bertoia Foundation

cat. 97
***Untitled,* mid-1970s**
Monel rods and tops on brass base

68 3/8 × 12 1/8 × 12 1/8 in. (173.7 × 30.8 × 30.8 cm)
Harry Bertoia Foundation

cat. 98
Untitled, 1970s
Inconel rods, bronze tops on brass base
67 1/4 × 12 1/8 × 12 1/8 in. (170.8 × 30.8 × 30.8 cm)
Harry Bertoia Foundation

cat. 99
Untitled, **c. 1970s**
Beryllium copper rods on brass base

85 × 16 × 8 in. (215.9 × 40.6 × 20.3 cm)
Harry Bertoia Foundation

cat. 100
Untitled, c. 1970s
Bronze tops silvered to beryllium
copper rods on brass base

42 1/4 × 12 × 12 in. (107.3 × 30.5 × 30.5 cm)
Harry Bertoia Foundation

cat. 101
Untitled, 1970s
Beryllium copper rods and tops
on brass base

60 7/8 × 17 × 5 in. (154.6 × 43.2 × 12.7 cm)
Harry Bertoia Foundation

cat. 102
Untitled, **mid 1970s**
Inconel rods and monel
cattail tops on brass base

55 × 12 × 11 7/8 in. (139.7 × 30.5 × 30.2 cm)
Harry Bertoia Foundation

cat. 103
Untitled, 1977
Beryllium copper rods and brass
tops on brass base

40 × 11 7/8 × 11 7/8 in. (101.6 × 30.2 × 30.2 cm)
Harry Bertoia Foundation

cat. 104
Untitled, 1970s
Monel rods and tops on brass base
41 × 10 1/4 × 10 1/8 in. (104.1 × 26 × 25.7 cm)
Harry Bertoia Foundation

cat. 105
***Untitled,* c. 1970**
Beryllium copper rods on brass base

30 1/2 × 8 × 8 in. (77.5 × 20.3 × 20.3 cm)
Harry Bertoia Foundation

cat. 106
Untitled, late 1960s
Beryllium copper rods on brass base

72 1/2 × 13 × 13 in. (184.2 × 33 × 33 cm)
Harry Bertoia Foundation

cat. 107
Untitled, mid-1970s
Monel tops and rods on brass base

60 1/2 × 12 1/8 × 12 1/8 in. (153.7 × 30.8 × 30.8 cm)
Harry Bertoia Foundation

cat. 108
***Untitled (Double Tonal)*, c. 1977**
Beryllium copper rods on brass base

36 × 19 1/4 × 7 7/8 in. (91.4 × 48.9 × 20 cm)
Harry Bertoia Foundation

cat. 109
***Gong,* 1970s**
Bronze

48 in. (121.9 cm) diameter
Harry Bertoia Foundation

cat. 110
Double Branched Gongs, 1970–71
Bronze sheet and welded bronze

103 × 55 × 58 in. (261.62 × 139.7 × 147.32 cm)
Allentown Art Museum, Gift of Audrey and Bernard Berman, 1982

Catalogue of Large-Scale Commissions

Marin R. Sullivan

The following 52 projects represent the most significant, well-documented large-scale commissions (works made for specific sites or architecture) that Bertoia realized over the course of his career. This list is not intended to be comprehensive but rather a thorough introduction to this aspect of Bertoia's artistic practice. Projects are listed chronologically and by the name and location of the site for which they were originally made. As with most of his other work, Bertoia rarely gave titles to his large-scale commissions, though some became associated with one after the fact and sometimes they were requested by the commissioning entity. When a project involved a close collaboration between the artist and architect, or the architectural firm is known, this name is also noted. Dates listed below designate when the work was completed or installed, not begun. Specific materials and dimensions are also included when known, with the latter listed as height by width by depth, unless otherwise specified. When possible, a photograph is included of the work in its original location.

There is no preexistent, authoritative record of such works. This list, however, originates with a hand-annotated record made by Bertoia in 1975, and additional archival documentation from the Harry Bertoia Foundation and the artist's Papers, currently held by the Vitra Design Museum in Weil am Rhein, Germany, and the Archives of American Art at the Smithsonian Institution in Washington, DC. Information was cross-referenced and supplemented from other primary sources, especially those related to the architects and patrons involved with respective commissions, contemporaneous press coverage, and criticism, but only direct quotes are cited.

1
General Motors Technical Center
Warren, Michigan
Eero Saarinen and Associates
1953
Brazed and welded steel
120 × 432 × 8 in.

This multiplane screen sculpture was the first large-scale commission completed by Bertoia, though it does not mark the first time he collaborated with architect Eero Saarinen. The two men had met and worked together in the early 1940s at the Cranbrook Academy of Art in Bloomfield Hills, Michigan. The General Motors Technical Center was one of Saarinen's earliest and most significant architectural projects, consisting of 25 buildings arranged in five distinct groups around a 22-acre artificial lake. Saarinen commissioned Bertoia as well as several other noted modern artists, including Alexander Calder, Marianne Strengell, and Antoine Pevsner, to create pieces across the corporate campus. Bertoia made his screen for the employee cafeteria in the Central Restaurant Building, where it divided the main dining area from the lobby. In Saarinen's architectural notes on the project, the screen was described "both in materials and in the syncopated rhythm of its design" as being "wholly of the twentieth century."[1]

2

Manufacturers Trust Bank
510 Fifth Avenue, New York
Skidmore, Owings & Merrill
1954
• Multiplane screen:
Brazed and welded metal
16 × 70 × 2 ft.
• Hanging "cloud" construction:
Steel wire
3 × 18 × 12 ft.

Gordon Bunshaft, who served as the supervising architect, personally commissioned Bertoia to create two works for the main banking area, located on the second floor of the new Manufacturers Trust Bank building. Bertoia was recommended by Eero Saarinen, who was a good friend of both men, and Bunshaft had seen the artist's work at the nearby Knoll Showroom. The smaller of the two works was a wire "cloud" sculpture hanging from the ceiling, but it was the massive, 70-foot-long brazed-metal sculpture that dominated the interior. Composed of seven major sections, with six horizontal bands arranged in five distinct vertical planes that stretched across them, the screen took Bertoia eight months to complete. He welded more organic, semi-abstract elements—irregularly hewn triangular, semi-circular, and trapezoidal shapes—to the structure, which gave the work a rich texture and immense formal complexity. The Architectural League awarded Bertoia the Gold Medal in Design and Craftsmanship for the project in 1955, with the committee making particular note of how well Bertoia integrated the screen with the building. In 2011, the interior of 510 Fifth Avenue became landmarked, and while the screen was temporarily removed and the building is now used as a retail space, the sculpture remains in its original location on the second floor, on permanent loan from Chase Bank.

3

Main Library, Cincinnati Public Library
Cincinnati, Ohio
Garber, Hughes & Associates
1954
Brazed and welded bronze; enameled metal flags
• Multiplane screen:
9 × 5 ft.

Like Gordon Bunshaft, architect Woodward "Woodie" Garber had seen Bertoia's work at the Knoll Showroom in New York during the early 1950s, prompting him to approach the sculptor about creating a work for his new modern library in downtown Cincinnati, which opened in 1955. Officially commissioned by the Public Library of Cincinnati and Hamilton County, the sculpture was a prevalent design element in Garber's original plans for the building. When the library opened to the public in 1955, visitors encountered a freestanding multiplane metal construction and color-plated metal "flags" in two shallow reflecting pools on the Children's Reading Garden terrace. In the 1980s, the library relocated the sculpture to a smaller terrace. Over subsequent years, the accompanying metal stakes were lost and the larger sculptural element dismantled and put into storage. A librarian recently found the missing sculptural parts and efforts are underway to reinstall all aspects of the work in a water feature at the library.

4
MIT Chapel, Massachusetts Institute of Technology
Cambridge, Massachusetts
Eero Saarinen and Associates
1955
Brazed steel
42 × 12 × 4 ft.

Two years after completing the General Motors Technical Center, Eero Saarinen and Bertoia collaborated again on the MIT (Kresge) Chapel. The 128-seat non-denominational chapel was one of two buildings Saarinen realized for the MIT Campus. It stood across from the Kresge Auditorium, which was the first large-scale concrete-shell building in the United States. The chapel had a circular footprint and a windowless interior, enlivened by a honeycombed oculus directly above the dramatic white-marble altar. Bertoia's metal sculptural screen—or, more accurately, a reredos or altarpiece—hangs from this single natural-light source, its 25 rods attached at both the ceiling and the floor. For the MIT Chapel commission, Bertoia took into account the function of the building as a place of worship, responding to the specifics of Saarinen's design and integrating it into his own. Bertoia affixed hundreds of vertical plates, each about 1.5 by 3 inches, to the vertical rods, mimicking the undulating rectangular bricks that emerge at varying depths across the walls of the space. He attached these plates in a variety of angles, combining them with small abstract shapes constructed from wire. Together these metal components give the screen a dynamic surface texture, enabling it to catch and reflect the light coming in from the oculus throughout the day.

5
Dallas Public Library
Dallas, Texas
George L. Dahl
1955
Brazed and welded copper, brass, and nickel alloys
10 × 24 ft.

The City of Dallas hired architect and Texas native George Dahl to build a new downtown central library facility on the site of the Carnegie Library, which had fallen into disrepair in the half-century since its opening in 1901. The specifics of how and why Dahl commissioned Bertoia for this project are unknown (there is no correspondence in either man's papers), but the architect had included an artwork in the original architectural design and corresponding budget for the building. In March 1955, relatively late in the process, Dahl hired Bertoia, paying him out of an allowance fund in the budget approved by the City and Library Board. Controversy erupted when then-mayor R. L. Thornton previewed the sculpture shortly after its installation and declared the work a "bunch of junk," and a cheap welding job to boot. While temporarily removed, the sculptural screen eventually became an iconic element of the Dallas Public Library. When the Old Library, as it is known today, permanently closed in 1983, Bertoia's screen was moved to the main atrium of the J. Erik Jonsson Central Library building, where it still resides.

6
Lambert–St. Louis Airport
St. Louis, Missouri
Hellmuth, Yamasaki & Leinweber
1955
Enameled metal
8 × 40 × 2 ft.

The new terminal at Lambert–St. Louis Airport (now St. Louis Lambert International Airport) was hailed as a modern marvel when it opened in 1956, particularly notable for its vaulted concrete roof. The project also marked the beginning of a fruitful professional and personal relationship between Bertoia and Minoru Yamasaki. The architect used Bertoia's screen to separate the dining area from the ticketing and check-in areas of the main concourse. It thus had a functional quality, like most of Bertoia's other screens from the mid-1950s. Furthermore,

the St. Louis screen was one of only a handful of works that were polychromed, or had applied color on the surface of the sculpture. One side of the screen featured cool-tone colors, the other warm. In a letter he wrote to Bertoia shortly after the terminal was finished, Yamasaki noted his displeasure that the restaurant had selected orange- and aqua-color chairs that clashed with the screen. While the architect was happy with the result, Bertoia noted of his experiment with color that the "model in the studio was beautiful, but somehow the result did not come up to expectations."[2] During an expansion at the airport between 1965 and 1967, the screen was removed; it is now lost and presumed destroyed.

7
Southdale Center
Edina, Minnesota
Victor Gruen Associates
1956
Bronze-coated steel
approx. 45 ft. high (each)

Located just outside Minneapolis, Victor Gruen's Southdale Center was one of the first and largest indoor shopping malls of the postwar period. Gruen had first approached Bertoia about creating a work for the Northland Shopping Center in Southfield, Michigan, but though the architect was enthusiastic about Bertoia's proposed design, his clients were not. For his next mall project, Gruen first secured the support of the anchoring department store, Dayton's, and then commissioned Bertoia to create a large sculpture for the Garden Court in front of the store's main entrance. The sculptor originally thought of making a monumental screen, but by early 1956 he settled instead on a vertically oriented design, allowing for more unimpeded movement of shoppers across the space. Bertoia proposed creating three "posts," but the architects ended up commissioning just two, describing the sculptures as "trees." Bertoia thought this fit well with the architectural concept of an interior, garden-like area, which, in addition to the sculpture, featured a sidewalk-style café, magnolia and eucalyptus trees, and caged birds. The work remains in its original location, though much of the mall has been renovated, and is now referred to by the title "Golden Trees."

8
United States Consulate General
Düsseldorf, Germany
Skidmore, Owings & Merrill
1956
Metal gong in metal frame
8 × 16 ft.

In the early 1950s, Gordon Bunshaft began working on designs for two new US Consulate buildings in Germany and asked Bertoia to create maquettes, or small models, for the projects. Bunshaft was one of many architects tasked with creating new postwar diplomatic structures during the period who approached Bertoia about possible commissions. Walter Gropius had contacted Bertoia about creating a sculpture for his US Embassy building in Athens, Greece, and the firm of Kahn & Jacobs had approached the artist for the US Mission to the United Nations building in New York, though neither project was realized. In 1955, the Office of Foreign Buildings Operation, the US Department of State, and the firm of Skidmore, Owings & Merrill officially commissioned the artist for consular buildings in Düsseldorf and Bremen (see next entry). For the new Düsseldorf Consulate General building, Bertoia created a unique rectangular gong, set inside a metal frame, which is unlike any other work he created during his prolific career and one of his earliest sounding sculptures. In 1958, the work was relocated to the Consulate General Office Building in Munich.

9
United States Consulate
Bremen, Germany
Skidmore, Owings & Merrill
1956
Welded metal
10 × 18 ft.

Very little is known about the history of this commission, which was the second con-
sular-building project Gordon Bunshaft led for Skidmore, Owings & Merrill in Germany
during the 1950s. Two years after Bertoia completed the work, it was featured as part
of an exhibition of five contemporary American sculptors shown in the official United
States Pavilion at the 1958 World's Fair (Expo) in Brussels, Belgium. Works by Bertoia (see next entry),
along with those by Alexander Calder, Isamu Noguchi, Mary Callery, and José de Rivera, were selected
on the recommendation of the Fine Arts Advisory Committee for not only the quality of their work but
also their "harmonious integration into the United States exhibit program."[3] The sculptures, all made
out of metal, were prominently featured in the open atrium of the pavilion on the ground level around a
center reflecting pool. The Bremen Consulate is now shuttered and the whereabouts of Bertoia's free-
standing metal multiplane screen are unknown.

10
United States Pavilion
World's Fair (Expo 58), Brussels, Belgium
Edward Durell Stone & Associates
1958
Brass, copper, and steel
92 × 78 × 48 in.

After being awarded a fellowship from the Graham Foundation for Advanced Studies in
the Fine Arts in 1957, Bertoia traveled back to Italy for the first time since emigrating to
North America, intending to take the year off from any major commissions or projects.
During this period, however, he was asked to contribute work to the US Pavilion at the
Brussels World's Fair, held in the Belgian capital from April to October 1958. Bertoia-
designed chairs filled the terrace surrounding the exterior of Stone's much-celebrated circular pavilion.
In addition to the screen from the Bremen consulate, Bertoia showed a large, golden tree-shaped
sculpture, which was installed on the lower level inside the pavilion around a shallow reflecting pool.
This piece was unlike other tree-like forms he created in the late 1950s, such as those for the Southdale
Center or the First Miami Bank, in that it expressed a new centrifugal form. Bertoia's later dandelion
sculptures emerged from this work, known as the "Golden Tree." Leslie Cheek Jr., the then director of
the Virginia Museum of Fine Arts in Richmond, had been on the advisory committee for the fair, and
Horace Gray Jr., a trustee of the museum, bought and donated the work to the instituition. It has resid-
ed at the museum since the conclusion of Expo 58 **(see cat. 59)**.

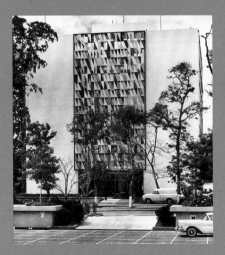

11
United States Embassy
Caracas, Venezuela
Oficina Don Hatch
1958
Dimensions and materials unknown

In 1948, American architect Don Hatch relocated to Caracas to serve as the chief architect
on the Venezuela Basic Economy Corporation, a project funded by the Rockefeller family. In
1951, he established his own firm and by 1958 he had secured the contract to design the new
US Embassy in the Venezuelan capital. He commissioned Bertoia to create a "screen" above
the entrance on the building's exterior. The work is related to the right-triangle motifs ap-
pearing in Bertoia's monotypes and other screen sculptures from the mid-1950s, but this is
the only commission to be built solely around this pattern. Like the screen for the Lambert–
St. Louis Airport, this piece also experimented with the application of alternating tones on the
individual metal plates. Hatch also owned and operated a high-end art gallery and design

196

showroom, the Galería Don Hatch, which featured Bertoia's artworks in multiple solo exhibitions beginning in 1956. Through collaborations with Hatch, Bertoia was able to introduce his work to new audiences, and many of his pieces ended up in private collections and Modernist homes, like the Gio Ponti designed Villa Planchart (1956). The original embassy building, located on the Av. De la Floresta in downtown Caracas, is today the Ministerio del Poder Popular para el Tursimo (Venezuelan Ministry of Tourism), but Bertoia's work remains *in situ*.

12
First National Bank
Miami, Florida
Knoll Planning Unit and Weed Johnson Associates
1958
Melt-coated brass over steel
137 × 55 × 30 in. (each)

In the late 1950s, First National Bank in Miami hired the Knoll Planning Unit, founded and led by Florence Schust Knoll, to create the interior of its new build-ing designed by architect Robert Law Weed. Knoll and Bertoia had first met at Cranbrook and were lifelong friends and colleagues. Bertoia created ten free-standing metal screens, which Knoll used as focal points within her decorative scheme. Two rows of five screens flanked the ends of the lobby, set in between pillars that lined up with the lighting tracks running through the geometrically patterned, illuminated ceiling. Between the two rows were *Continua* wall screens by Erwin Hauer, *Barcelona* chairs designed by Ludwig Mies van der Rohe, and bespoke counters and desks. The bases of the sculptures were bolted to the concrete slab and then covered with the stone floor, creating the appearance of tree trunks growing out from the ground. This, along with their branch and leaf forms and placement in a bank, led to the sculptures being referred to as the "Money Trees." The bank eventually moved to a new location and decided to sell the sculptures. Victor Elmaleh, a University of Virginia trained architect, purchased the screens, displaying them for a time at the Pacific Design Center in Los Angeles before donating them to his alma mater in 2000. The School of Architecture decided to sell the works at auction in 2014 to fund a doctoral program, and they have now been dispersed to various private collections.

13
First National Auto Bank Oklahoma
Tulsa, Oklahoma
McCune, McCune & Associates
1959
Welded bronze
20 × 7 ft.

For the First National Auto Bank, Bertoia created a sculptural foundation, another commission involv-ing a water feature. Designed by a local architectural firm led by brothers Murray and Gordon McCune, the building was Tulsa's first drive-through bank, located at 620 South Cincinnati Avenue. The sculpture was originally installed in an artificially lit reflecting pool near the main entrance of the bank. Streams of water spouted from the edges of the geometric leaf-like shapes attached to the three tall posts composing the central core of the work, which were connected by additional welded forms. The bank closed in the 1980s and underwent several mergers before eventually changing its name to Liberty Bank and Trust Company. The sculpture was relocated to a sunken plaza near First Place Tower in downtown Tulsa shortly thereafter. Over time, it fell into disrepair and ceased to function as an oper-ating fountain. In 2016, when plans were approved to develop the plaza into a parking garage, Stuart Price of Price Family Properties announced they would donate the sculpture to the Tulsa City-County Library system, and the work was moved to the Central Library branch in downtown Tulsa.

14
Zenith Showroom
Chicago, Illinois
Shaw, Metz & Dolio
1959
Brazed and welded bronze and brass
142 1/4 × 231 1/4 × 81 in.

In 1959, the Zenith Radio Corporation opened a new display salon on Michigan Avenue in downtown Chicago: it was not a store, its function being that of presenting and highlighting the company's cutting-edge radios and televisions. The main architect, Alfred Shaw, and his clients came up with the idea of one striking red wall featuring a thematic artwork as the only décor element, and approached Bertoia for the commission. Originally the artist proposed a singular spherical object, but Shaw suggested that he consider making a sculptural group to create more visual interest. Zenith was initially hesitant to incur the cost, not seeing any connection between the symbolism of Bertoia's proposed work and what the company actually sold. Shaw and Bertoia continued to modify the design and the final sculpture, with its pulsing electric light and three smaller objects, more overtly suggested the transmission of radio and television. Bertoia said of the work, "We live in a time dominated by these invisible forces. It is, in a sense, these forces, these elements of the atomic and electronic age, that I am trying to give sculptural shape and form."[4] Zenith closed the showroom and donated the work to the Smithsonian American Art Museum in 1979, where it is now displayed under the title *Sculpture Group Symbolizing World's Communication in the Atomic Age* (see cat. 63).

15
Eastman Kodak Company
Rochester, New York
1960
Welded bronze
5 × 2 ft.

In 1960, the Eastman Kodak Company opened a new office reception center at its headquarters in Rochester. In the main-floor lobby, Bertoia's metal sculpture hung on a patterned wall behind a sitting area and near an open staircase with a black-marble lily pool underneath. Though smaller in scale, the sculpture is formally similar to the other welded cluster or burst commissions he realized for Zenith and other corporate clients in the late 1950s. In the 1970s, the work was donated to the Rochester Institute of Technology and installed on the wall of the second-floor lobby of James E. Booth Hall, which houses the College for Imaging Arts and Sciences.

16
Denver Hilton Hotel
Denver, Colorado
I. M. Pei and Associates
1961
• Screen:
Welded metal
8 × 12 × 4 ft.
• Dandelion:
Stainless steel, bronze alloy, and marble
137 1/2 × 75 × 75 in.

The Denver Hilton Hotel was part of a major urban redevelopment project in downtown Denver (known variously as the Denver Mile High Center, Courthouse Square, and Zeckendorf Plaza) led by the developer William Zeckendorf and the architectural firm of Pei, Cobb, Freed & Partners (I. M. Pei and Associates). Architect Araldo Cossutta designed the hotel, now the Downtown Denver Sheraton, which is the only remaining structure from the project. The architects commissioned Bertoia to create two works for the hotel. A freestanding metal screen was placed on a short marble platform near the windows in the lobby. Also sometimes referred to as "Money Trees,"

the screen was actually composed of two tree-like forms welded together. The work was given to the Denver Art Museum in 1970 and subsequently sold via a private gallery in 1979. The second work, Bertoia's first commissioned dandelion sculpture, was created for the hotel's Columbine Bar. Placed on a white-marble base, it stood in the middle of the circular bar at the center of the space. Its thousands of radiating wires, extending from a stainless-steel central orb, provide a contrast to the rigid geometry of the Mo-Sai panels on the hotel facade, visible through the windows behind it. The sculpture was removed from the hotel at some point prior to its sale at auction in 2013. It is now in the collection of the Crystal Bridges Museum of American Art in Bentonville, Arkansas.

17
St. John's Unitarian Church
Cincinnati, Ohio
Garber, Tweddell & Wheeler
1961
Phosphor-brass rods and copper
12 × 2 ft.

Originally commissioned as an outdoor sculpture for the facade of the church, this work was the result of a creative collaboration between Bertoia and the architect, John Garber. The two men exchanged numerous letters and undertook trips—Garber to Bertoia's studio in Pennsylvania and Bertoia to the site in Cincinnati—during the construction process. The funding for the project came from the church, of which Garber was a member. This meant that all expenditures, including the proposed sculpture, had to be voted on by a quorum of the congregation. As the building was already over budget at the time of the commission, another vote had to be taken, and, in the end, Garber and other members of the congregation contributed additional funds to cover the costs. A dedication ceremony took place on September 11, 1961; soon after Garber wrote to Bertoia that the sculpture had "become an integral part of the building and an integral part of the Sunday worship service." The architect also noted how the combination of the light coming in through the windows and the irregular rhythm of the work's form caused its surface to shimmer and pulse. "Due to the mathematical inevitability, the sculpture always manages to be sunlit at some dramatic moment—say when the organ reaches a climax or when the sermon begins or when a Christening is taking place."[5]

18
Albright-Knox Art Gallery
Buffalo, New York
Skidmore, Owings & Merrill
1961
Tobin bronze over iron tubes
80 3/4 × 162 1/4 × 23 3/8 in. (overall)

In the 1950s, the Albright Art Gallery hired Buffalo-native Gordon Bunshaft and his architectural firm to design an addition for the museum. The architect commissioned Bertoia to create a sculpture for a lounge and restaurant space in the new building. The work comprises four sections of thick metal tubes that can be arranged together as a screen or placed as individual entities within the dining space. In a letter to Bunshaft that demonstrates their collaborative relationship, Bertoia described having the first "unit" "well advanced" and asking the architect to visit his studio in Pennsylvania. "I have located the tubes where they seem right and will weld them after you have had your say. We'll work together for about an hour or so."[6] The addition was dedicated in early 1962 and the institution renamed the Albright-Knox Art Gallery in honor of Seymour H. Knox, Jr., who had underwritten the building. Bertoia's screens, in a variety of configurations, remained on view in the restaurant continuously until 2008, when they were removed and placed in storage.

19
Syracuse University
Syracuse, New York
King and King Architects
1962
Bronze and steel
36 × 117 × 66 in.

Arthur J. Pulos, a professor of industrial design at Syracuse University, contacted Bertoia in 1960, inviting him to create a "suspended sculptural object" for the lobby of a new classroom building on campus. A year later, the architectural firm of King and King officially commissioned the sculptor to create the work for the Huntington Beard Crouse Building. Unlike with other projects, Bertoia did not visit Syracuse until the building was completed, in late 1961, but he did correspond with the architects on lighting, means of suspension, weight, and materials, as well as consult the architectural drawings they had sent him early in the process. The work was installed in 1962, suspended from the ceiling in the lobby, just outside the Gifford Auditorium. Officially a gift from the Chi Omega Sorority, Upsilon Alpha Chapter, to Syracuse University, Bertoia's sculpture was named "Nova" (sometimes referred to as the "Syracuse Nova") after a suggestion from Bertoia, though he also jokingly offered the title, "Flying Haystack."

20
Bankers Trust Building
280 Park Avenue, New York
Henry Dreyfuss and Emery Roth & Sons
1962
Bronze, brass, copper
74 × 90 × 4 in.

Bertoia did not work directly with an architect or architectural firm on the sculpture for the new Bankers Trust Building, designed by Emery Roth & Sons. Instead, the commission was facilitated through his New York gallery, Staempfli, and the Pasadena-based interior- and industrial-design firm of Henry Dreyfuss, which had been hired to design the building's interiors. Dreyfuss had previously created the iconic vault at the Manufacturers Trust Building, another project that featured works by Bertoia. The resulting cluster of golden metal rods hung against a travertine wall of an open staircase on the seventeenth floor. In a letter to Bertoia, Dreyfuss wrote: "This week 280 Park Avenue opens its doors for business. All of us involved expended our top efforts to make this the finest bank that imagination, skill and craftsmanship could create. ... I wanted to take this opportunity to add my personal thanks and tell you how beautifully I feel your sculpture has become a part of our architectural interior."[7] The work is no longer *in situ* and its current whereabouts are unknown.

21
Dulles International Airport
Chantilly, Virginia
Eero Saarinen and Associates
1962
Spill cast bronze
96 × 432 × 4 in.

Much like the Lambert–St. Louis Airport, Dulles International Airport was lauded as a monument of Modernism and technological innovation when it was dedicated and opened by President John F. Kennedy in November 1962. Eero Saarinen, the architect responsible for the overall design, unexpectedly passed away in September 1961. Kevin Roche took over and commissioned Bertoia, who created a sculptural wall consisting of four tons of bronze, shaped into nine sections, each four feet wide. This was the first large-scale commissioned work in which he deployed a unique sculptural process he called "spill casting." The panels for Dulles were all poured in about 24 hours, though Bertoia had experimented and perfected the technique over the span of a year. The panels were placed in front of the entrance to the restaurant on the main floor of the terminal. An official summary created by the Federal Aviation Agency at the time describes the sculpture as depicting "the awareness of

the relationship of man and space and the formative process occurring within our planet through time."[8] Whether Bertoia (who was rarely inclined to make statements about the meaning of his works) agreed with this assessment or not, the rough, gnarled surface and complex, earthy patina of the Dulles sculpture does evoke a primordial, geologic landscape. Today, the work remains on the mezzanine level, just beyond the main security checkpoint, moved slightly from its original location during a recent renovation of the airport.

22
Perpetual Savings & Loan
Los Angeles, California
Edward Durell Stone & Associates
1962
Stainless steel and 24-karat-gold plated nickel wire
18 × 11 ft. diameter

Like almost all of Bertoia's large-scale commissioned pieces, this massive dandelion sculpture was constructed in segments at his studio in Bally, Pennsylvania, and then shipped to its final destination, Beverly Hills. The sculptor was on hand to complete the assembly of the work, which was officially dedicated on January 2, 1963. Weighing almost half a ton, it took Bertoia more than five months to complete and consisted of almost 84,000 separate pieces of wire. The sculpture was placed in a 28-foot artificially lit lagoon with a fountain feature that arced streams of water toward its base in front of the eight-story building designed by Edward Durell Stone. This is the largest dandelion sculpture realized by Bertoia. Within a few years, however, the gold plating on the wires started to flake and peel off, and a decision was made in 1966 to dismantle the work rather than restore it. In 1970, the Joslyn Art Museum in Omaha, Nebraska, expressed interest in acquiring the "Sunburst," and by 1972 it was installed in its Fountain Court. When the museum underwent a remodel in 1988, the sculpture was moved to the Milton R. Abrahams Branch of the Omaha Public Library. The atrium where the work continues to reside was designed specifically to accommodate this large sculpture.

23
Stemmons Towers
Dallas, Texas
1964
• "The Family":
Melt-coated brass over bronze
40 × 15 × 15 1/2 in. (1964)
93 3/4 × 50 3/4 × 19 1/2 in. (c. 1961)
74 × 22 × 15 in. (1963)
• Spray:
Cupro-nickel
74 × 22 × 18 in. (1964)

These four works were purchased as a group for the main plaza of the new Stemmons Towers office complex at 2730 Stemmons Freeway in Dallas. Installed on concrete bases in a shallow reflecting pool at the center of the four office buildings, the abstract sculptures became known as "The Family," owing to their resemblance to a familial group. Mrs. and Mr. Edmund J. Kahn, who had previously purchased works by Bertoia from the Knoll Showroom in Dallas and were friends with the Stemmons Towers developer Trammell Crow, helped facilitate the commission. The sculptor had originally proposed creating two sculptures specifically for the site, but he added a third, preexisting sculpture to the group of three figures and also incorporated a tonal "spray" that would make sound when moving in the wind. The pieces were all de-installed from the plaza in Dallas, with the "spray" sold separately from the three bronze pieces. All four are now in private collections.

24

Northwestern National Life Insurance Company
Minneapolis, Minnesota
Minoru Yamasaki Associates
1964
Brass-coated steel rods
14 × 46 × 4 ft.

In 1962, Minoru Yamasaki contacted Bertoia about creating a sculptural screen for the lobby of his new Northwestern National Life building in downtown Minneapolis. By the following year, John Pillsbury, president of NWNL, and Yamasaki officially commissioned the piece and by the end of 1964, a massive, golden sculpture glistened on a specially constructed white-marble shelf in the lobby. The space had been conceived and modified with the sculpture in mind, a result of extensive correspondence between artist and architect concerning aesthetic and structural issues. Bertoia worked for a year on the sculpture, which was constructed in 600-pound sections that were discretely attached at junction points and rested on "feet" that were inconspicuously formed by inverted apexes of clustered rods. The work was set about two feet off the wall and lit for maximum effect. Composed of thousands of brass-coated steel rods that give the appearance of sheaths of harvested grain, the sculpture contrasts with and draws focus in the stark lobby. Though Bertoia rarely gave titles to his work, Pillsbury specifically requested he do so, and they settled on "Sunlit Straw." Northwestern National Life Insurance Company was subsequently sold and, while now owned by Voya Financial, the work remains in its original location.

25

W. Hawkins Ferry Residence
Grosse Pointe, Michigan
Meathe, Kessler and Associates
1964
Brass-coated steel rods
14 ft. high, 3 ft. diameter

In 1963, noted arts patron, collector, and architectural historian W. Hawkins Ferry and architect William Kessler commissioned Bertoia to create a sculpture for the former's new residence in Grosse Pointe, a suburb of Detroit. The sculptor frequently received requests from individuals to create works for their homes, and while he agreed to many, the resulting sculptures were usually small in scale. He was initially hesitant to take on Ferry's request as he was in the midst of the Northwestern National Life commission, but after visiting the site during construction, Bertoia sent a few sketches for the proposed project. Called "The Comet" by its owner, the monumental work stretched 14 feet and was hung near the main stairwell of the home, though there had been some discussion during the design process over whether it should be placed on a pedestal instead. After the work was installed in the spring of 1964, Ferry wrote to Bertoia, "The piece is perfect for the space; and when the spotlight is turned on, the effect is positively brilliant."[9] The work included welded brass-coated rods like Bertoia's other straw-and-cluster pieces, but also included red, brown, and turquoise coloring on various organic-looking clusters at the ends of some of the rods. Following Ferry's death in 1988, the sculpture was removed from the residence and gifted to the Detroit Institute of Arts, the museum his grandfather helped found.

26

Golden West Savings
Castro Valley, California
Mario Louis Gaidano
1964
Brass-coated steel rods
20 ft. diameter

Very little is known about the circumstances of this commission, which is one of only a handful of sculptures Bertoia created for sites on the West Coast. Formally similar to the other straw pieces he made in 1964, this large sculpture hung from multiple points in the ceiling of the main lobby and banking area at a newly opened location of Golden West Savings, designed by local mid-century architect Mario Louis Gaidano. Golden West would later be

bought out by Wachovia and then Wells Fargo, and the current whereabouts of the sculpture, sometimes referred to by the title "Galaxy," are unknown.

27

Eastman Kodak Pavilion
New York World's Fair
Kahn and Jacobs, Architects
1964
24-karat-gold stainless-steel wire and bronze
Dimensions variable

The second commission Bertoia received from the Eastman Kodak Company was for its pavilion at the 1964–65 New York World's Fair. He created seven sculptures collectively known as the "Golden Dandelions," the largest of which was 18 feet tall and 6 feet in diameter, with over 75,000 individual wires making up its spherical top. The project involved complex engineering, as the sculptures were installed in a large fountain inside the pavilion with jets of streaming water and required special lighting. The work was dismantled at the end of the fair, but in 1975 Kodak donated the sculptures to the Rochester Institute of Technology in upstate New York, where they still reside today.

28

Robertson Hall, Woodrow Wilson School of Public and International Affairs, Princeton University
Princeton, New Jersey
Minoru Yamasaki Associates
1965
Bronze rods and copper tubing
54 in. diameter

Around the time Bertoia was working on the Northwestern National Life project, Minoru Yamasaki commissioned him to create a freestanding sculpture for the lobby of the Woodrow Wilson School at Princeton University. Keen to get Bertoia's input on the overall design of the interior, Yamasaki sent him layouts of the furniture placement and detailed descriptions of the finishes and color scheme of the space. Known as "The World," the orb-like sculpture is made up of thousands of bronze rods emanating from a central core, recalling a globe—a particularly apt form given its location in a school dedicated to international affairs. However, as the artist noted in a letter to the architect in 1963, any overt features found on an actual globe were not necessary since "we can see that in the National Geographic."[10] While made specifically for this building, the Princeton work recalls many of the "bush" sculptures Bertoia created throughout his career, though this commission represents one of the largest examples of the type.

29

Cuyahoga Savings Association
Cleveland, Ohio
Arthur Lawrence Associates
1965
Stainless steel and stainless-steel wire
126 × 138 in.

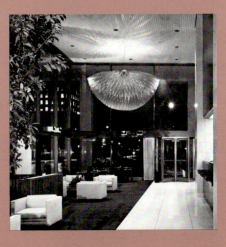

The architectural firm of Arthur Lawrence Associates, along with bank president Clarence P. Bryan, commissioned Bertoia to create this work as part of the interior design for the Cuyahoga Savings Association building in downtown Cleveland. Though resembling other large-scale dandelion or sunburst sculptures previously realized by Bertoia, this commission is unique as it is only a hemisphere, or, as architect Arthur Lawrence referred to it, an "inverted umbrella."[11] Nearly 12 feet across, the sculpture hung from a single wire affixed to the ceiling in the lobby of the bank, just past the revolving-door entrance and visible from the street through the glass curtain walls. The carefully lit wires of the sculpture cast dynamic patterns on the ceiling and served as a shimmering focal point in the space. In 2007, the global financial services firm Morningstar acquired the work and installed it, hanging from the ceiling, in the two-story atrium café space of its new headquarters in Chicago's Loop.

30
River Oaks Shopping Center
Calumet City, Illinois
Loebl, Schlossman, Bennett & Dart
1966
Tobin bronze rods
9 × 10 × 8 ft.

Made for the new River Oaks Shopping Center, this commission marks the first time Bertoia created a large-scale tonal work, that is, intended to make noise as it moves with wind currents. Bertoia's Chicago gallery, Fairweather and Hardin, helped broker the commission, which had come about due to the admiration of the artist's work by Jerrold Loebl, one of the architects on the project. Bertoia undertook a significant amount of research into what materials and thicknesses might best withstand winds and inclement weather. He explored the possibility of both hollow and solid rods in an attempt to achieve the best tonal effects. He eventually settled on one-and-a-half-inch-thick Tobin bronze rods. Installed in the center of a fountain in front of a Marshall Field's department store, the rods were welded at the bottom to a metal base, elevated above the water. They were arranged in a far more irregular, curvilinear manner than most of his later tonals. As art historian June Kompass Nelson remarked, however, "Apparently [Bertoia] overcorrected for Chicago's windy conditions as, unfortunately, the sound is heard only occasionally. He calculates now that he could change the situation by extending the rods."[12] The work was removed at some point, and its current whereabouts are unknown.

31
Federal Court Building
Brooklyn, New York
Carson, Lundin & Shaw
1967
Laminated, textured, and painted asbestos squares
36 × 24 × 3 ft.

Recalling the experiments in color undertaken for the Lambert–St. Louis Airport, this unusual screen was commissioned by the General Services Administration (GSA) for the Federal Court Building in Brooklyn's Civic Center. Bertoia had been selected on the recommendation of the project's architects, Carson, Lundin & Shaw. Installed at one end of a long, marble-clad lobby between a metal-and-glass staircase and a glass curtain wall, the screen hung from the ceiling and almost reached to the floor of the double-height interior. Comprised of hundreds of identically shaped 24-inch squares, hung in four rows or planes, the work created a powerful visual impact while also allowing light to filter into the space. The squares were made of laminated asbestos, all painted on both sides in shades of orange, yellow, and white. The color scheme had the effect of amplifying the warmth of sunlight as it streamed into the space or conversely, of brightening it up when such light was absent. Perhaps not surprisingly, given the health risks of the chosen material and its location in a federal building, the work was eventually dismantled. The work remains in storage, and a maquette of the screen, made in painted wood and string, is in the collection of the Smithsonian American Art Museum in Washington, DC.

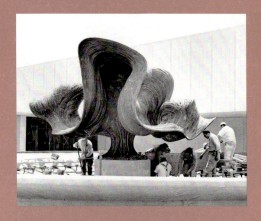

32
Civic Center Plaza
Philadelphia, Pennsylvania
Davis, Poole and Sloan and Edward Durell Stone
1967
Copper tubing and phosphor-bronze welding rods
14 × 16 × 10 ft.

In the mid-1960s, Philadelphia began construction on a new Civic Center, and the city's pioneering Percent for Art program required that art be created for the site. Based on the recommendations of the Center's architects, as well as Edward Durell Stone, who served as a consultant on the project, the Philadelphia Arts Commission contracted Bertoia to create a sculptural fountain for the 45-foot plaza in front of the Civic Center. He used 11,000 feet of copper tubing, welded together with bronze rods, to

create the sculpture. Sometimes called "Free Interpretation of Plant Forms," the work was so massive and labor intensive that he had to fabricate it outside, behind his studio, working with two assistants beginning in the summer of 1966. Bertoia quipped to a local newspaper during the work's installation, "You heard of the copper shortage last summer. This is probably one of the reasons." He continued, "I can't put into words what I put into metal. But first of all, we have to think of it as public property. It is there to be seen and enjoyed by anyone who finds it enjoyable. It was my intent to produce something that was both gentle and strong."13 When the Civic Center was demolished in 2000, the sculpture was moved to a purpose-built municipal shed for storage and in 2016, it was relocated to the Woodmere Art Museum in Philadelphia, where it now resides as a working fountain on the grounds.

33
Whiting Auditorium
Flint, Michigan
Smith, Hinchman & Grylls Associates
1967
Gold-plated stainless-steel wire
7 ft. diameter

Commissioned and installed in 1966, this large, gilded orb was created for the lobby of the James H. Whiting Auditorium, a performing arts space in Flint, Michigan. The commission was facilitated by the J. L. Hudson Gallery in Detroit, rather than directly by the client or the architect, though Bertoia did correspond with Sigmund F. Blum, the lead architect on the project. Created from some 675 gold-plated stainless-steel wires, the work resembles Bertoia's other dandelion and sunburst sculptures from the period. However, it did not top a metal pole or support, but was hung from a single anchor point in the ceiling. Originally meant to be 8 feet in diameter, it was slightly reduced in size as the building went up in order to better fit with the architecture. Though some of the architects and clients suggested to Bertoia that perhaps an elliptical rather than symmetrical circle would be better, the sculptor was insistent that it remain a sphere. Lit from above and visible from both levels of the lobby through a central opening, the resulting work glistens and spreads a warm glow throughout the space. The sculpture remains in its original location.

34
Procter Hall, University of Cincinnati
Cincinnati, Ohio
Garber, Hughes & Associates
1968

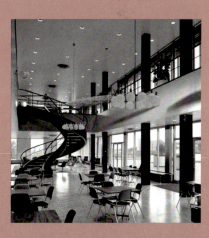

Architect Woodie Garber and Bertoia remained friends after the completion of the Cincinnati Public Library project in the mid-1950s. They attempted to work together on a proposed design for a library at Cornell University that would have involved two of the exterior walls being clad in colorful panels designed by the artist, but the project went to another firm. They collaborated again, however, when Garber was awarded the job for Procter Hall at the University of Cincinnati. The building, made to house the University's College of Nursing and Health, was partially funded by Procter & Gamble heiress Mary E. Johnston. Garber commissioned one of Bertoia's clouds, similar in form to the ones at Syracuse University and Manufacturers Trust, to hang over the central staircase of the building. Though modifications, especially to the exterior cladding, have recently been made to the building, the Bertoia sculpture remains in its original location.

35
Union Building, Rochester Institute of Technology
Rochester, New York
Kevin Roche, John Dinkeloo & Associates
1968
Spill cast bronze
48 × 54 × 54 in. (each)

In the late 1960s, the Rochester Institute of Technology moved from downtown Rochester to a new campus in nearby suburban Henrietta. One percent of all construction costs were set aside for the purchase of art, and a committee that included RIT trustee Arthur L. Stern and American Craft Council founder Aileen Osborn Webb led the selec-

tion process. In addition to works by artists including Josef Albers and Henry Moore, three large bronze planters by Bertoia were commissioned for the glass-roofed concourse of the Union Building designed by Kevin Roche, John Dinkeloo & Associates. The architectural firm conceived a number of buildings for the new campus and had previously worked with the sculptor at Dulles Airport. Bertoia created the square boxes for RIT using his spill cast technique. Today, the planters are installed in the atrium of the Golisano Building on the campus.

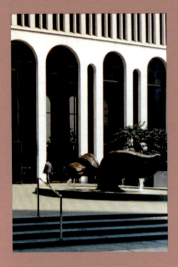

36
Manufacturers & Traders Trust
Buffalo, New York
Minoru Yamasaki Associates
1968
Copper tubing and bronze welding rods
7 × 18 × 12 ft.

A 21-story office tower designed by Minoru Yamasaki dominates the Manufacturers & Traders Bank Plaza in downtown Buffalo. From the very beginning, both the architect and client placed great importance on the commissioning of a large-scale sculpture for the plaza, seeing it as an integral design element. Henry Moore was briefly considered for the project, but Bertoia was selected after receiving several sketches and design models and thanks to the emphatic endorsement of Yamasaki. Installed in the center of an oval reflecting pool, the sculpture was illuminated by underwater lights and its swirling forms, accentuated by water, channeled up through sixteen connections that cascaded down across its surface. The green patina of the sculpture dialogued with the white Taconic and green Verde Antique marble selected by Yamasaki for the facing of the building as well as the green plantings placed throughout the plaza. The fountain basin was also lined with one-inch greenish-white mosaic tile. Bertoia, Yamasaki, bank officials, and members of the Buffalo community were on hand in August 1968 for the official unveiling ceremony. The work has remained in its original location ever since.

37
Seattle First National Bank
1001 Fourth Avenue, Seattle, Washington
Naramore, Bain, Brady & Johanson
1968
Stainless steel wire
8 × 30 × 30 ft. (overall)

This group of 36 sculptures hung from the ceiling of the banking lobby of the Seattle First National Bank building in downtown Seattle. The bank purchased or commissioned more than two hundred major works of art for both the building's interiors and the large outdoor plaza, which would also eventually feature Henry Moore's *Vertebrae* (1968). Resembling Bertoia's other "willow" sculptures, each piece was constructed from thousands of stainless-steel wires draped over central points. During the construction process, it was determined that the sculptures were best lit from inside and Bertoia worked with the architects and electrical engineers to develop a specialized lighting system. The artist traveled to Seattle to install the sculptures, which were grouped in one, two, and three units of varying sizes and diameters. The model he created for the project was also displayed inside the bank as a separate standing floor piece. In 1983, Seattle First, or Seafirst as it was then known, was acquired by Bank of America and a majority of works made for the downtown headquarters, including Bertoia's hanging pieces, were subsequently sold.

38
Genesee Valley Center
Flint, Michigan
Victor Gruen Associates and Louis G. Redstone Associates
1970
Brass coated steel
24 × 18 ft.

J. L. Hudson Art Galleries, and more specifically its director, Oscar Piagentini, again played an important role in facilitating a Michigan-based commission for Bertoia, this time for a new shopping mall in Flint. Victor Gruen Associates and Louis G. Redstone Associates had designed many such structures

around the state during the postwar period and frequently incorporated large-scale artworks. For this project, they commissioned Bertoia to create a hanging piece for one of the open courts. The sculpture hung from a single anchor point and comprised two parts: a more horizontally oriented cluster over 17 feet long, 11 feet wide, and over 4 feet high, which was attached to the lowest point of an upper, more vertical unit that measured just over 19 feet high and 8 feet in diameter. In 1980, the sculpture was removed from the Genesee Valley Mall and relocated to Northland Center in Southfield, Michigan, also designed by Victor Gruen back in 1954. The work was discovered in the basement of the mall prior to its demolition in 2017 and is currently owned by the city of Southfield.

39
Lake Clifton Senior High School, #40
Baltimore, Maryland
Smeallie, Orrick and Janka
1970
Copper tubing and bronze welding rods
12 × 8 × 8 ft.

Like a number of Bertoia's large-scale commissions, this project was facilitated through a Percent for Art program that required a specific percentage of the construction of new civic buildings be devoted to fine art. Bertoia was recommended by G. Holmes Perkins, a dean at the University of Pennsylvania, but officially commissioned for the project in 1967 after the architects, Eugene Smeallie, John Riggs Orrick, and Martin Janka visited his Bally studio. Due to civic bureaucracy, Bertoia did not submit his plans for the sculpture to the Baltimore Board of Education until 1969 and official approval to proceed was not granted by the City until March 1970. Completed and installed in late 1970, the sculpture dominates what was called the Art Court at the high school, an outdoor space located near the auditorium, library, and administrative offices in the vicinity of the front entrance. The work, described by Bertoia as a "folding and unfolding membrane," formally resembles the fountains created for the Philadelphia Civic Center and M&T Bank.[14] For now the sculpture, which is in need of substantial conservation, remains in its original location, though the school has undergone significant changes over the subsequent decades.

40
Marshall University
Huntington, West Virginia
1972
Copper tubing and bronze welding rods
14 × 9 × 9 ft.

In the wake of a tragic plane crash that killed seventy-five members of the Marshall University football team on November 14, 1970, four memorials were constructed on the school's campus. Bertoia created a fountain for the plaza outside the Marshall University Student Center, renamed the Memorial Student Center after a major renovation in the 1990s. The sculpture rests atop a circular pedestal in the center of a reflecting pool, with water propelled through the inner core of the piece. Memorial services are still held every year on the anniversary of the crash, which include the laying of a wreath and turning off the water on the fountain until the following spring. Though the work is abstract, a bronze plaque of remembrance was included on the base, which reads: "They shall live on in the hearts of their families and friends forever, and this memorial records their loss to the university and to the community."

41
National Bank
Boyertown, Pennsylvania
Shenk, Seibert, Smithgall Architects
1974
Copper tubing and bronze welding rods
8 × 8 × 3 ft.

The National Bank of Boyertown commissioned Bertoia to create a fountain in celebration of its hundredth anniversary. The sculpture was installed near the sidewalk in front of the entrance of the bank's new building. While still conceived in Bertoia's abstract style, the fountain's form refer-

ences the bank's tulip logo. Like his other fountain commissions, Bertoia engineered this work so that water would move over its surface, in this case spouting up from the "stem" and flowing down the "petals." Today the sculpture still functions as a fountain, but now resides in front of the Miller Center for the Arts at the Reading Area Community College in nearby Reading, Pennsylvania.

42
Standard Oil of Indiana Building
Chicago, Illinois
Edward Durell Stone & Associates
1974
Beryllium copper rods and naval brass plates
Dimensions variable

This commission marked the last major collaboration between Edward Durell Stone and Bertoia and was the most monumental and ambitious installation of the sculptor's tonals, or sound sculptures, in an outdoor location. Bertoia placed eleven sculptures, composed of varying numbers of rods (from two to one hundred), in heights ranging from 4 to 16 feet, in a black-granite-clad reflecting pool in front of Stone's Standard Oil Building, or "Big Stan," as it would be colloquially called. Though Bertoia took great care to make sure the sound effects of the work could be heard, because the plaza was sunken below street level and surrounded by other wall fountains, the movement of the rods was sometimes drowned out. The work was dedicated on June 24, 1975, to great fanfare, but there was so little wind that Bertoia waded out with a mallet and "played" the work for dignitaries like Mayor Richard J. Daley and former First Lady, Lady Bird Johnson. In the 1990s, the plaza underwent significant renovations and today only six of the sculptures remain on site at what is now the Aon Center, separated into two groups on opposite sides of the building. Of the five works removed from the site, two are unaccounted for and three were sold at auction in 2013. An additional plaza renovation was completed in 2021.

43
A. Price Woodard Park
Wichita, Kansas
1975
Copper tubing and bronze welding rods
18 × 9 × 10 ft.

In 1972, the Department of Parks and Recreation of the City of Wichita acquired downtown riverfront land from the federal Urban Renewal Agency and used it to create a civic green space. Bertoia's sculpture, like the name of this new park, honors A. Price Woodard, who was the first African-American mayor of Wichita. It was installed on a circular concrete base and nearby a separate plaque on an additional concrete base was included, its inscription reading: "Sculpture by Harry Bertoia. This work of art is dedicated to A. Price Woodard. Mayor of Wichita, Attorney, Member of the Board of Education, and Humanitarian. A. Price Woodard was a friend of all and gave his community a free and open spirit." Given the title "Interrupted Flight," it was the last large-scale sculpture Bertoia made using the technique of fused-copper tubing and bronze welding rods. The sculpture remains in the downtown park, while the Wichita Art Museum owns the maquette.

44
Annenberg Center, University of Pennsylvania
Philadelpia, Pennsylvania
Vincent G. Kling
1975
Bronze and naval brass
35 × 8 × 8 ft.

When initially approached in 1974 about a commission for a new center for the performing arts at the University of Pennsylvania, Bertoia requested the plans and section drawings for the lobby, especially those related to the well area, where his sculpture would eventually be placed. He submitted several proposals, some of which, as Bertoia wrote, "contend solely with a visual effect, others embody a

motion of sorts and sound." In the end, the center's benefactors, Walter and Leonore Annenberg, approved a design that did not possess any tonal qualities but was rather unique in form and effect with respect to most of Bertoia's other commissioned work. Known as "Homage to Performing Arts," the sculpture is constructed of thick hanging wires attached to discs set at different intervals, extending downward through multiple levels of the building. These pieces are hung from a single central bronze wire attached to the ceiling of the lobby.

45
Sun Company Corporate Headquarters
Radnor, Pennsylvania
John Carl Warnecke
1976
Brass, bronze, and steel
72 in. diameter

Betty Bowes, a Pennsylvania artist, facilitated this commission for the Sun Company (previously Sun Oil, now Sunoco). Bowes, whose husband was a Sun executive, corresponded with Bertoia and he sent her photographs of similar works to present on his behalf to the company during the construction process of its new executive headquarters. Related to Bertoia's previous straw and sunburst sculptures, this commission was made with the form of the building and the name of the company in mind. The "radial construction," as Bertoia referred to the piece, hung from the ceiling of the open "well" of the main reception area, glistening with its golden, patinated surface, like a pulsing solar orb.

46
Colorado National Bank
Denver, Colorado
Minoru Yamasaki Associates
1976
Beryllium copper rods on naval brass plate
220 × 96 × 48 in.

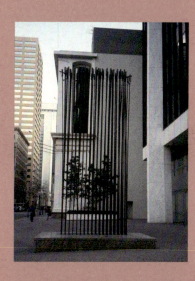

In the mid-1970s, the Colorado National Bank engaged Minoru Yamasaki to design a new downtown office tower, which opened in 1975 and is now known at the US Bank Tower. Yamasaki commissioned Bertoia to create a massive 18-foot-tall tonal sculpture for the plaza in front of the building. The work comprised ninety beryllium-copper rods, each with a thicker "cattail" top. Though copper was the most expensive option, Bertoia insisted that this material be used because of its "toughness and sound quality," especially important due to the work's placement outdoors in a busy urban environment.[15] The Colorado National Bank also purchased a 15-foot tonal with thirteen rods that was installed inside the building. Both sculptures were some of the largest tonals Bertoia ever made, but each was removed and sold during the late 1980s.

47
University of Akron
Akron, Ohio
Thomas T. K. Zung Architects
1976
Beryllium copper rods and brass plate
Dimensions variable

Before starting his own architectural firm in Cleveland, Thomas Zung worked for Edward Durell Stone and through him, he first came into contact with Bertoia on the Philadelphia Civic Center project. Zung became a close friend of Bertoia's and an admirer of his work, especially his sound sculptures. When hired to design the new Music, Speech, and Theater Arts Building (now Guzzetta Hall) at the University of Akron, Zung worked with the administration to secure grant funding that enabled the commissioning and installation of a group of Bertoia tonal sculptures for the atrium lobby of the recital hall. The five tonals, with heights ranging from 4 to over 8 feet, arranged in varying configurations, were placed on a 5 foot × 5 foot × 2 inch brass base. Visitors invited at the

dedication ceremony on March 31, 1976 were encouraged to play with and touch the sculptures. Zung told the local newspaper that a building dedicated to music, speech, and theater had "all the right ingredients" to make an ideal setting for Bertoia's sounding sculptures.[16]

48

Allentown-Bethlehem-Easton (A-B-E) Airport
Allentown, Pennsylvania
Wallace & Watson Associates
1976
Bronze and brass plate
145 × 72 × 72 in.

In 1975, the Executive Committee of the Lehigh-Northampton Airport Authority commissioned Bertoia to create a large sculpture for the new passenger terminal building at the Allentown-Bethlehem-Easton Airport (now the Lehigh Valley International Airport). Bertoia's home and studio were nearby, so the project had local significance for him. The resulting piece comprised two rows of bronze rods, 9 feet in length, and two rows of similar rods, 12 feet in length, attached in a perpendicular formation on a square brass plate. This configuration hung from the ceiling over the escalators and stairs connecting the two floors of the terminal. Sometimes referred to as "Reflecting a Calm," the sculpture was de-installed and placed in storage in 2010.

49

Bowling Green State University
Bowling Green, Ohio
Thomas T. K. Zung Architects
1976
Tobin bronze rods
120 × 42 × 42 in.

By the end of their collaboration for the University of Akron, Zung and Bertoia had already moved on to another project for nearby Bowling Green State University. This commission was a single tonal sculpture, composed of more than fifty bronze rods with "cattail" tops. Originally installed outside the Zung-designed Alumni Center building of the BGSU campus, the work was removed in 1979 due to vandalism and temporarily placed in storage. The school relocated the work two more times during the 1980s, the second time to its current location outside the Fine Arts Building.

50

Sentry Insurance Headquarters
Stevens Point, Wisconsin
Bennett Johnson
1977
Naval brass
6 × 18 × 1 ft.

Bertoia worked with architect Bennett Johnson on a large-scale tonal sculpture for the fourth-floor executive waiting area of the new headquarters of Sentry Insurance in northern Wisconsin. Johnson corresponded with Bertoia early on in the project, informing the artist of the interior design decisions that had already been made, including the choice of beige carpets, rift-oak walls, and dark-bronze hardware. From the very beginning, the sculpture was intended to be installed in front of a solid wall, and while the artist had initially suggested a succession of five rows of rods, the final work had only three. Bertoia constructed the sculpture in three sections, each 6 feet in length, leaving it up to the architect to decide if any space was to be left in between them when installed.

51

Federal Reserve Bank of Richmond
Richmond, Virginia
Minoru Yamasaki Associates
1978
Beryllium-copper rods and naval-brass plate
18 × 6 × 6 ft.

This was Bertoia's sixth and last large-scale commission with Minoru Yamasaki, completed shortly before the artist's death. As was typical when Bertoia accepted a commission, architectural drawings of the site were sent, but this time they came with a suggestion from Yamasaki that he consider placing the sculpture on the east–west axis of the reflecting pool in front of the 26-story, aluminum-clad skyscraper. The work comprised two semi-circular halves, one 18 feet tall, the other 16, each with 55 copper rods. Bertoia stated that as he could not create something to compete with the bulk of the building, he created something more intimate but with a similar visual effect. Local reporters expressed skepticism when the sculpture arrived on a flatbed truck, but after its installation, they were delighted by not only how well it reinforced the verticality of the building, but also the way the rods swayed and chimed in the breeze.[17]

52

Cleveland Public Library, Glenville Branch
Cleveland, Ohio
Thomas T. K. Zung Architects
1979
Brass
56 1/2 × 65 × 12 in.

Bertoia's last collaboration with Thomas Zung, and the very last commission he designed before his death in November 1978, was for the new Glenville Branch of the Cleveland Public Library. The tonal sculpture was comprised of a single line of 55 rods. Val Bertoia, the sculptor's son, installed in the work in 1979.

1 Eero Saarinen Collection, Box 137, Folder 263, Manuscripts and Archives, Sterling Memorial Library, Yale University.

2 June Kompass Nelson, *Harry Bertoia: Sculptor* (Detroit: Wayne State University Press, 1970), 24.

3 "5 U.S. Sculptors For Fair Chosen," *New York Times*, October 27, 1957.

4 Harry Bertoia, as quoted in a Zenith Radio Corporation press release, "New Bertoia Sculpture Unveiled at Zenith Salon" (July 23, 1959). Smithsonian American Art Museum Object Files.

5 Letter from John Garber to Harry Bertoia, November 1, 1960, Harry Bertoia Papers 1917–1979, Archives of American Art, Smithsonian Institution (hereafter Bertoia Papers).

6 Undated letter from Harry Bertoia to Gordon Bunshaft, Bertoia Papers.

7 Letter from Henry Dreyfuss to Harry Bertoia, December 5, 1963, Bertoia Papers.

8 "Historical Summaries," Dulles International Airport, Bureau of National Capital Airports, Federal Aviation Agency (undated), provided to the author by the Metropolitan Washington Airports Authority.

9 Letter from Hawkins Ferry to Harry Bertoia, April 7, 1964, Bertoia Papers.

10 Letter from Harry Bertoia to Minoru Yamasaki, August 13, 1963, Bertoia Papers.

11 Letter from Arthur Lawrence to Harry Bertoia, August 23, 1965, Bertoia Papers.

12 Nelson, 37.

13 Harry Bertoia, as quoted in Len Kucinski, "Imagination the Prime Factor, Bally Sculptor Says of His Work," *Morning Call* (Allentown, Pennsylvania), May 10, 1967.

14 Undated statement by Harry Bertoia, Bertoia Papers.

15 Letter from Harry Bertoia to Yamasaki, April 24, 1973, Bertoia Papers.

16 William Bierman, "Celestial' Sculpture Dedicated at Akron U," *Akron Beacon Journal*, April 1, 1976.

17 Roy Proctor, "Bertoia's Outdoor Cathedral," *Richmond News Leader*, July 8, 1978.

Selected Chronology

1915

Arri Bertoia is born on March 15 in San Lorenzo di Arzene (Pordenone, Friuli region), Italy.

1930

Emigrates to Canada and then joins his older brother, Oreste (1908–1971), who worked at a Ford Motor Company factory in Detroit, MI.
Takes a year of Americanization classes at the Davison School, where he begins to learn English.

1931

Enrolls at the Elizabeth Cleveland Intermediate School in Detroit.

1933

Transfers to Cass Technical High School, where he receives numerous awards for his drawings, prints, and jewelry.
The Cranbrook Academy of Art in Bloomfield Hills, MI opens. Finnish architect Eliel Saarinen designs its campus and serves as its first president, holding the position until 1946.

1936

Receives a scholarship to the School of the Detroit Society of Arts and Crafts, where he studies painting for one year with John Carroll and Sarkis Sarkisian.

1937

Applies for a scholarship to attend the Cranbrook Academy of Art in Bloomfield Hills and is accepted as a student of painting. Part of his scholarship package includes managing the Academy's metal shop.
Charles Eames arrives at Cranbrook Academy of Art to study with Eliel Saarinen, who invites him to join the faculty in fall 1939—a position Eames will hold until he relocates to Southern California in 1941.

1939

Eliel Saarinen hires Bertoia to teach metalcraft. Bertoia becomes the youngest member of the faculty.
A design team at Cranbrook, led by Eliel and Eero Saarinen, wins the two-stage competition for the Smithsonian Gallery of Art to be built on the National Mall in Washington, DC. Bertoia forges and casts metal elements on the model that accompanies their submission. The project is never realized.

1940

Meets Brigitta Valentiner, who enrolled at Cranbrook for the fall semester; she is the daughter of Wilhelm Valentiner, the noted art historian and then director of the Detroit Institute of Arts.
Collaborates with Charles Eames and Eero Saarinen on their submissions to the Museum of Modern Art's *Organic Design in Home Furnishings* competition, creating tiny hammered copper prototypes. Eames and Saarinen's winning chairs are shown in the exhibition of the same name held at the museum in 1941.
Begins making monotypes or single impression prints, a practice he will continue throughout his life.

1941

Wadsworth Atheneum in Hartford, CT acquires 24 monotypes, a set Bertoia collectively titled *Synchromy, No. 5*, for the museum's collection.

1942

During his final year at Cranbrook (1942–43) teaches only printmaking due to metal shortages caused by World War II.

1943

Marries Brigitta Valentiner on May 10.
Solicits feedback on his monotypes from Hilla Rebay, the founding director of the Museum of Non-Objective Painting in New York (later the Solomon R. Guggenheim Museum). Rebay purchases all 99 prints he had sent her for review and acquires 43 more over the following months.
Begins professional relationship with Karl Nierendorf and his eponymous gallery in New York.
Moves to Southern California in September to work for Charles Eames in the Molded Plywood Division (MPD) of the Evans Product Company.
Learns to weld at the Santa Monica City College.

1944

Work featured for the first time in the April issue of *Art & Architecture*.
Birth of daughter Mara Lesta.
Meets and befriends artist and filmmaker Oskar Fischinger and his wife Elfriede in August.

1945

First solo gallery exhibition, *Harry Bertoia*, opens at the Nierendorf Gallery in New York in January, followed by his first solo museum exhibition, *Abstractions by Harry Bertoia*, which opens at the San Francisco Museum of Art in March.

Severs ties with Eames and the MPD in December.

1946

Begins to make metal sculpture.

Becomes an American citizen.

Numerous pieces of jewelry included in *Modern Handmade Jewelry*, an exhibition at the Museum of Modern Art in New York featuring pieces from artists, including Alexander Calder and Margaret De Patta, who became associated with American studio jewelry during the mid-twentieth century.

1947

Karl Nierendorf dies suddenly in October of a heart attack.

Takes a job as a technical and scientific illustrator at the U.S. Navy Electronics Laboratory at Point Loma near San Diego, CA.

1949

Birth of son Val Odey.

1950

At the invitation of Hans Knoll and Florence Knoll (née Schust) of Knoll Associates, Bertoia moves to Eastern Pennsylvania near the Knoll factory in Pennsburg, temporarily settling in New Hope over the summer.

1951

Knoll establishes a metal workshop for the company in Bally, PA.

Makes the first prototypes of what will become the Diamond Chair (Knoll model 421).

Becomes close friends with designer George Nakashima and his wife, Marion.

Production begins on the Bertoia Bench (Knoll model 400), the first piece of furniture he creates for Knoll, which is comprised of wood slats on welded wire base. The bench goes on the market in 1952.

1952

Rents farmhouse and land in Barto, PA. In 1959, he purchases the property and will live there for the rest of his life.

Knoll introduces the Bertoia Collection of wire furniture at their New York City showroom at 575 Madison Avenue in December as part of a large-scale presentation of his design and artistic practice. *The Art of Harry Bertoia: Paintings – Drawings – Metal Sculpture – Chairs* features examples of the Diamond Chair (Knoll model 421), the Large Diamond Chair (Knoll model 422), the Side Chair (Knoll model 420), and the Bird Chair (or High Back Chair) as well as its Ottoman (Knoll models 423 and 424).

1953

The Bertoia Collection goes into production and appears for the first time on the official Knoll price sheet on April 15.

Bertoia decides to stop designing furniture for Knoll in order to focus fulltime on his sculptural practice. However, he continues to work with the company as a design consultant and assists with additions to the Bertoia Collection until the late 1950s. Bertoia establishes his primary studio at the former Knoll metal workshop in Barto.

Completes his first large-scale commission for the employee cafeteria in the Central Restaurant Building of the Eero Saarinen-designed General Motors Technical Center in Warren, MI. Over the next two years will undertake numerous high-profile large-scale commissions with important modernist architects, including Saarinen again on the MIT (Kresge) Chapel at the Massachusetts Institute of Technology; Gordon Bunshaft of Skidmore, Owings, and Merrill on the Manufacturers Trust Building at 510 Fifth Avenue in New York; and Minoru Yamasaki on the St. Louis Lambert Airport.

Becomes the Visiting Critic in Sculpture at Yale University in New Haven, CT for the 1953–54 academic year.

1955

Knoll begins production of the Child's Side Chair (Knoll model 425) and the Baby Bertoia (Knoll model 426), a miniaturized version of the Side Chair.

Presents slide lecture entitled "Light and Structure" at the International Design Conference in Aspen, CO.

Birth of daughter Celia Marei.

Begins professional relationship with the Fairweather Hardin Gallery in Chicago.

Awarded the Gold Medal in Design and Craftsmanship from the Architectural League of New York for his work on the metal screen for the Manufacturers Hanover Trust Building.

1956

First solo exhibition of sculpture at the Fairweather Hardin Gallery.

Awarded Craftsmanship Medal by the American Institute of Architects (AIA).

Knoll releases the plastic Molded Shell Side Chair. While made of fiberglass through the early 1970s, Knoll will re-introduce this version of the Side Chair in 2017 with a seat made from glass reinforced nylon.

Smithsonian Institution organizes the exhibition *Recent Work by Harry Bertoia* that travels until 1958 to 13 museums throughout the United States and Canada.

1957

Receives a $10,000 grant from the Chicago-based Graham Foundation for Advanced Studies in the Fine Arts. He attends six-week seminar in January and February in Chicago. The grant gives Bertoia financial freedom and enables him to visit Italy for the first time since he emigrated—the only time he would return to the country.

1958

Solo exhibition *Esculturas de Harry Bertoia* (Sculptures of Harry Bertoia) opens in April at the Galería Don Hatch in Caracas, Venezuela. Bertoia also collaborates with the eponymous gallery owner and architect on a commission for the United States Embassy in Caracas. Two sculptures by Bertoia are exhibited in the Edward Durell Stone-designed United States Pavilion at the World's Fair in Brussels, Belgium.

1959

Begins professional relationship with the Staempfli Gallery in New York.

The Graham Foundation includes two sculptures by Bertoia in its *Exhibition of Recent Works of Past Graham Fellows*. According to Bertoia scholar Sydney Skelton Simon, one of these works, *Study in Sound* (1959), marks one of the first examples of his sounding sculptures.

The Museum of Modern Art includes two Bertoia sculptures in its exhibition *Recent Sculpture U.S.A.*, which opens in New York on May 13 before traveling to four other venues across the United States through 1960.

1960

Begins experimenting with bush-like forms in his sculpture, in which he welds complicated arrangements of branching bronze rods to a central core, usually comprised of a copper tube.

1961

Develops his spill-casting technique following a visit with filmmaker Clifford "Bud" West (his Cranbrook student and friend) on Ossabaw Island off the coast of Georgia and a tour of the Anaconda American Brass Company in Waterbury, CT, during which Bertoia witnesses thousands of pounds of molten bronze spilling out of an unattended furnace. His largest application of this technique is for a sculpture he creates later this year in collaboration with the architect Kevin Roche for Eero Saarinen's Dulles International Airport in Chantilly, VA. Saarinen dies unexpectedly, before the airport is completed.

1963

Included in the triennial exhibition *Sculpture in the Open Air* held in Battersea Park, London, along with British and American artists such as Alexander Calder, Anthony Caro, John Chamberlain, Barbara Hepworth, Henry Moore, David Smith, Richard Stankiewicz, and Peter Voulkos.

1965

Clifford West releases a documentary film on the artist, *Harry Bertoia's Sculpture.*

1969

Working with local carpenter Walter McCauley, Bertoia finishes renovating the barn on his homestead in Barto and begins to fill the space with sounding sculptures.

1970

Presses the first LP of taped recordings of sounding sculptures installed in the barn on his property at Allentown Record Company. The two sides of the album were titled *Bellissima Bellissima Bellissima* and *Nova*. Begins professional relationship with the Benjamin Mangel Gallery in Philadelphia.

1971

Filmmakers Jeffrey and Miriam Eger complete a 16mm film, *Sonambients: The Sound Sculptures of Harry Bertoia*, which was re-released in 2017 on DVD.

1972

Participates in an oral history interview with Paul Cummings for the Archives of American Art. Introduced by Clifford West to Norwegian art dealer Kaare Bernsten, who begins to show his work in Oslo. Bertoia travels to Norway several times over the next six years, including for a major exhibition of his sounding sculptures at Grieg Hall in Bergen in 1978.

1973

Awarded the Fine Arts Medal by the American Institute of Architects for distinguished achievement in the fine arts relating to architecture.

1975

Unveils largest commission, created for the plaza in front of the Edward Durell Stone-designed Standard Oil Building (now AON Center) in Chicago, IL. *Harry Bertoia*, a retrospective of his sculpture and graphics, curated by Beverly Twitchell, opens on December 14 at the Allentown Art Museum in Pennsylvania.

1976

Travels throughout Peru, Guatemala, and Mexico.

1978

Though battling lung cancer, remains professionally active, creating and exhibiting new work. Dies at home on November 6 and is buried on his property in Barto, beyond the barn under a ten-foot, one-ton gong.

1979

Ten more *Sonambient* LPs, produced by Bertoia shortly before his death, are released. These were re-released as a CD box set in 2015 by Important Records.

1980

Fifty Drawings, a limited-edition book of monotypes, is published by his Estate, as instructed by Bertoia before his death.

2005

Knoll brings the Asymmetrical Chaise (Knoll model 429) to market for the first time, though it was originally designed in the early 1950s.

Solo exhibitions

1945
Harry Bertoia, Nierendorf Gallery, New York, NY.
Abstractions by Harry Bertoia, San Francisco Museum
of Modern Art, San Francisco, CA.
Exhibitions of Monoprints by Harry Bertoia,
Phillips Collection, Washington, DC.

1954
Harry Bertoia, The New Gallery, Charles Hayden
Memorial Library, Massachusetts Institute of
Technology, Cambridge, MA.

1956
Recent Work by Harry Bertoia, Smithsonian Institution
Traveling Exhibition Service. Traveled to San Francisco
Museum of Modern Art, 1956; Stanford Art Gallery,
1956; Colorado Springs Fine Arts Center, 1956; Fine
Arts Department, Indiana University, 1957; Institute of
Contemporary Arts, Corcoran Gallery, 1957; Philadelphia
Art Alliance, 1957; Baltimore Museum of Art, 1957;
George Thomas Hunter Gallery of Art (now Hunter
Museum of Art), 1957; Cranbrook Academy of Art, 1957;
Lamont Art Gallery, Phillips Exeter Academy, 1957; Lowe
Art Center, Syracuse University, 1957; Walker Art Center,
1958; School of Architecture, University of Manitoba,
1958; Fairweather Hardin Gallery, Chicago, IL.

1958
Recent Work by Harry Bertoia, Walker Art Center,
Minneapolis, MN.
Esculturas de Harry Bertoia, Galería Don Hatch,
Caracas, Venezuela.

1961
Bertoia, Fairweather Hardin Gallery, Chicago, IL.
Harry Bertoia: Recent Sculpture, Staempfli Gallery,
New York, NY.
*Colección de mueblas Knoll / Esculturas de Harry
Bertoia*, Knoll International, Museo de Arte Moderno
de Buenos Aires, Buenos Aires, Argentina.

1963
Bertoia: Recent Bronzes, Staempfli Gallery,
New York, NY.

1965
Staempfli Gallery, New York, NY.

1968
Harry Bertoia: Recent Sculpture, Staempfli Gallery,
New York, NY.

1970
Harry Bertoia, Staempfli Gallery, New York, NY.

1972
Harry Bertoia, Galleri K.B. Kaare Bernsten, Oslo,
Norway.

1973
Bertoia, Court Gallery, Copenhagen, Denmark.

1974
Sensations in Sculpture, Wadsworth Atheneum,
Hartford, CT.
Mitchell Art Museum, Mount Vernon, IL.

1975
Monotypes of Harry Bertoia, Olympia Galleries,
Glenside, PA.
Harry Bertoia, Fairweather Hardin Gallery, Chicago, IL.
Sculpture by Harry Bertoia, Art Institute of Chicago,
Chicago, IL.
*Harry Bertoia: An Exhibition of His Sculpture and
Graphics* [retrospective], Allentown Art Museum,
Allentown, PA.

1976
Harry Bertoia, Staempfli Gallery, New York, NY.

1977
40 Esculturas por Harry Bertoia, Edificio Anauco,
Parque Central, Caracas, Venezuela.
Sculpture by Harry Bertoia, Fairweather Hardin Gallery,
Chicago, IL.
Harry Bertoia, Marshall University Art Gallery,
Huntington, WV.

1978
Harry Bertoia: Recent Sculptures, Staempfli Gallery, New York, NY.

1979
Harry Bertoia: A Retrospective, Benjamin Mangel Gallery, Bala Cynwyd, PA.

1980
Bertoia: The Work of Harry Bertoia, Cranbrook Art Museum, Bloomfield Hills, MI.
Harry Bertoia, Sculpture in Colorado Collections, Colorado Springs Fine Arts Center, Colorado Springs, CO.

1981
Harry Bertoia 1915–1978, Staempfli Gallery, New York, NY.

1990
The Bertoia Legacy: Sound and Motion, Payne Gallery, Moravian College, Bethlehem, PA.

2001
Harry Bertoia: Visualizing Sound, Cranbrook Art Museum, Bloomfield Hills, MI.

2005
Harry Bertoia: Sight-Sound-Function, Sculpture and Furniture from Four Decades, Maxwell Davidson Gallery, New York, NY.

2006
In Nature's Embrace: The World of Harry Bertoia, Reading Public Museum, Reading, PA.

2009
Harry Bertoia: Decisi che una sedia non poteva bastare (Harry Bertoia: It All Started with a Chair), Museo Civico d'Arte, Pordenone, Italy.

2010
Harry Bertoia: Works on Paper and Sculpture, Lehigh University Art Galleries, Bethlehem, PA.

2011
Harry Bertoia: The Traveling Show, Seraphin Gallery, Philadelphia, PA. Traveled to Kean University Galleries, *Harry Bertoia: Works on Paper and Furniture*; Rosemont College, *Harry Bertoia: Four Decades of Drawing*; Marshall M. Fredericks Sculpture Museum at Saginaw State University, *Harry Bertoia: Abstract Drawings*; Gallery 210, University of Missouri–St. Louis, *Harry Bertoia: Forty Years of Drawing*; Philip and Muriel Berman Museum of Art at Ursinus College, *Harry Bertoia: Drawings & Sculpture*; Susquehanna Art Museum, *Harry Bertoia: Four Decades of Drawing*.

2012
Harry Bertoia: Sound and Vision, Johnson Museum of Art, Cornell University, Ithaca, NY.

2013
Harry Bertoia: Structure & Sound, Michener Museum, Doylestown, PA.

2014
All Things Bertoia, Montana State University, Bozeman, MT.

2015
Bent, Cast & Forged: The Jewelry of Harry Bertoia, Cranbrook Art Museum, Bloomfield Hills, MI.

2016
Atmosphere for Enjoyment: Harry Bertoia's Environment for Sound, Museum of Arts and Design, New York, NY.
Reverberations: Sound Sculpture by Harry Bertoia, Allentown Art Museum, Allentown, PA.

2018
Harry Bertoia: Sculptor and Modernist Designer, San Antonio Museum of Art, San Antonio, TX.

2019
Harry Bertoia: Soundings, Philip and Muriel Berman Museum of Art at Ursinus College, Collegeville, PA.

Group exhibitions

1939
Exhibition of the Work of Academy Staff, Cranbrook Art Academy, Bloomfield Hills, MI.

1940
Contemporary American Industrial Art: 15th Exhibition, Metropolitan Museum of Art, New York, NY.

1943
Loan Exhibition (Exhibition 24), Museum of Non-Objective Painting, New York, NY.

1944
Loan Exhibition (Exhibition 25), Museum of Non-Objective Painting, New York, NY.
Advanced Trends in Contemporary American Art, Detroit Institute of Arts, Detroit, MI.
100 Twentieth Century Prints from Ten Countries: Argentina, Belgium, England, France, Germany, Italy, Mexico, Norway, Spain, the United States, Institute of Modern Art (now Institute of Contemporary Arts), Boston, MA.
Art in Progress: Paintings, Prints, Sculpture, Museum of Modern Art, New York, NY.
Loan Exhibition (Exhibition 26), Museum of Non-Objective Painting, New York, NY.

1945
Loan Exhibition (Exhibition 28), Museum of Non-Objective Painting, New York, NY.
Loan Exhibition (Exhibition 30), Museum of Non-Objective Painting, New York, NY.
Loan Exhibition (Exhibition 31), Museum of Non-Objective Painting, New York, NY.

1946
Modern Handmade Jewelry, Museum of Modern Art, New York, NY.
1946 Annual Exhibition of Contemporary American Painting, Whitney Museum of American Art, New York, NY.

1947
Girard Studio, Grosse Pointe, MI.
American Exhibition of Painting and Sculpture 58th Annual: Abstract and Surrealist American Art, Art Institute of Chicago, Chicago, IL.

1949
An Exhibition of Modern Living, Detroit Institute of Arts, Detroit, MI.

1953
Good Design, Museum of Modern Art, New York, NY.

1954
61st Annual American Exhibition of Paintings and Sculpture, Art Institute of Chicago, Chicago, IL.

1956
Craftsmanship in a Changing World, American Craftsmen's Council, Museum of Contemporary Crafts, New York, NY.

1957
American Exhibition of Painting and Sculpture 62nd Annual, Art Institute of Chicago, Chicago, IL.
Irons in the Fire: An Exhibition of Metal Sculpture, Contemporary Arts Museum, Houston, TX.

1958
Beloit College Neese Fund Collection, Milwaukee Art Institute (now Milwaukee Art Museum), Milwaukee, WI.
Sculpture 1950–1958, Allen Memorial Art Museum, Oberlin College, Oberlin, OH.
Living Today, Corcoran Gallery of Art, Washington, DC.
Annual Exhibition: Sculpture, Paintings, Watercolors, Drawings, Whitney Museum of American Art, New York, NY.
Pittsburgh Bicentennial International Exhibition of Contemporary Painting and Sculpture, Carnegie Institute, Pittsburgh, PA.

1959
Recent Sculpture U.S.A., Museum of Modern Art, New York, NY. Traveled to Denver Museum of Art, 1959; Los Angeles County Museum, 1960; City Art Museum of St. Louis, 1960; Museum of Fine Arts, Boston, 1960.
Exhibition of Recent Works of Past Graham Fellows, Graham Foundation for Advanced Studies in the Fine Arts, Chicago, IL.

1960
Business Buys American Art, Whitney Museum of American Art, New York, NY.
Aspects de la sculpture américaine (Aspects of American Sculpture), Galerie Claude Bernard, Paris, France.
Annual Exhibition 1960: Contemporary Sculpture and Drawings, Whitney Museum of American Art, New York, NY.

1961
Drawings USA, Saint Paul Gallery and School of Art, Saint Paul, MN.
Contemporary American Sculpture and Painting, Krannert Art Museum, University of Illinois, Urbana, IL.
1961 Pittsburgh International Exhibition of Contemporary Painting and Sculpture, Carnegie Institute, Pittsburgh, PA.
Edward Wales Root Bequest, Munson-Williams-Proctor Arts Institute, Utica, NY.

1962
Annual Exhibition 1962: Contemporary Sculpture and Drawings, Whitney Museum of American Art, New York, NY.

1963
Contemporary American Painting and Sculpture,
Krannert Art Museum, University of Illinois, Urbana, IL.
Sculpture in the Open Air, London County Council,
Battersea Park, London, UK.

1964
Stone, Wood, Metal, Staempfli Gallery, New York, NY.
The Sculptor and the Architect, Staempfli Gallery,
New York, NY.
Annual Exhibition: Contemporary American Sculpture,
Whitney Museum of American Art, New York, NY.

1966
Art in Chicago Business, Fairweather Hardin Gallery,
Chicago, IL.
Drawings U.S.A. 1966. Third Biennial Exhibition, Saint
Paul Art Center, Saint Paul, MN.
Traveled to Allentown Art Museum; Columbia Museum
of Art; Carleton College; Witte Memorial Museum;
Colorado Springs Fine Art Center; College Art Center,
Wooster; Asheville Art Museum; Civic Fine Arts Center,
Sioux Falls; Sioux City Art Center; Wichita Art Museum;
Municipal Art Center, Los Angeles; Tweed Gallery,
Duluth; Charleston Art Gallery, West Virginia; Joslyn
Art Museum.
First Flint International, Flint Institute of Arts, Flint, MI.
*Annual Exhibition 1966: Contemporary Sculpture and
Prints,* Whitney Museum of American Art, New York, NY.

1967
*Exhibit of Paintings and Sculpture by Harry Bertoia,
Earl Hine, Joseph Nichols, and Leon Kazmierczak,*
Reading Public Museum and Art Gallery, Reading, PA.

1972
Knoll au Louvre, Musée du Louvre, Paris, France.

1973
*Sound/Sculpture: A Survey of Work by 11 Audio-Kinetic
Sculptors,* Vancouver Art Gallery, Vancouver, British
Columbia, Canada.

1974
*Painting, Sculpture and Works on Paper: Selected from
the Collection of Mr. and Mrs. Leslie L. Johnson,* Laguna
Beach Museum of Art (now Laguna Art Museum),
Laguna Beach, CA.

1975
American Prints 1913–1963, Museum of Modern Art,
New York, NY.
*Exhibition of Work by Newly Elected Members and
Recipients of Honors and Awards,* American Academy
of Arts and Letters, New York, NY.
Invitational Sculpture Exhibition, Hunterdon Art Center,
Clinton, NJ.

1976
Sounds of Sculpture, Taft Museum, Cincinnati, OH.

1981
Soundings, Neuberger Museum of Art, Purchase
College, State University of New York, Purchase, NY.

1983
Design in America: The Cranbrook Vision, 1925–1950,
Detroit Institute of the Arts, Detroit, MI. Traveled
to Metropolitan Museum of Art, New York; Suomen
Rakennustaiteen Museo, Helsinki; Musée des arts
décoratifs, Paris; Victoria and Albert Museum, London.

1996
*Twentieth-Century American Sculpture at the
White House: The Nation's Capital,* White House,
Washington, DC.

1999
*Twentieth-Century American Sculpture at the
White House: The View from Denver,* White House,
Washington, DC.

2001
*Vital Forms: American Art and Design in the Atomic
Age, 1940–1960,* Brooklyn Museum of Art, Brooklyn,
NY. Traveled to the Walker Art Center; Frist Center for
the Visual Arts; Los Angeles County Museum of Art;
Phoenix Art Museum.

2008
*Sensory Overload: Light, Motion, Sound and the Optical
in Art Since 1945,* Milwaukee Art Museum, Milwaukee,
WI.

2011
*The Spirit of Modernism: The John R. Eckel, Jr.
Foundational Gift of the Museum of Fine Arts, Houston,*
Museum of Fine Arts, Houston, TX.
*Crafting Modernism; Midcentury American Art and
Design,* Museum of Arts and Design, New York, NY.
Traveled to Memorial Art Gallery, Rochester, 2012.
*San Diego's Craft Revolution: From Post-war Modern
to California Design,* Mingei International Museum,
San Diego, CA.

2014
*When Modern Was Contemporary: the Roy R.
Neuberger Collection,* Neuberger Museum of Art,
Purchase College, State University of New York,
Purchase, NY.

Selected Bibliography

Archival material

Harry Bertoia papers, 1917–1979. Archives of American Art, Smithsonian Institution.

Dissertations

Simon, Sydney Skelton. "Harry Bertoia and Postwar American Design." Stanford University, Stanford, CA, 2018.

Books and exhibition catalogues

American Art at the Flint Institute of Arts. New York: Flint Institute of Arts, in association with Hudson Hills Press, 2003.

Art in Progress: A Survey Prepared for the Fifteenth Anniversary of the Museum of Modern Art, New York. New York: Museum of Modern Art, 1944.

Ball, Victoria Kloss. *The Art of Interior Design: A Text in the Aesthetics of Interior Design.* New York: MacMillan Company, 1960.

Bernsten, Kaare. *Bertoia.* Copenhagen: Court Gallery, 1973.

Bertoia, Celia. *The Life and Work of Harry Bertoia: The Man, the Artist, the Visionary.* Atglen, PA: Schiffer Publishing, 2015.

Design in America: The Cranbrook Vision, 1925–1950. New York: Harry Abrams, Inc. in association with the Detroit Institute of Arts and the Metropolitan Museum, 1983.

Edward Wales Root Bequest. Utica, NY: Munson-Williams-Proctor Institute, 1961.

Fallino, Jeannine. *Crafting Modernism: Midcentury American Art and Design.* New York: Abrams in association with the Museum of Arts and Design, 2011.

Fitzpatrick, Tracy and Nicole Bass. *When Modern Was Contemporary: the Roy R. Neuberger Collection.* Purchase, NY: Neuberger Museum of Art of Purchase College, SUNY, in association with the American Federation of Arts, 2014.

Ganzer, Gilberto. *Harry Bertoia: Decisi che una sedia non poteva bastare (Harry Bertoia: It All Started With a Chair).* Cinisello Balsamo (Milan): Silvana Editoriale, 2009.

Girard, Alexander H. and William D. Laurie, Jr. *An Exhibition for Modern Living.* Detroit: Detroit Institute of Arts, 1949.

Greenbaum, Toni. *Messengers of Modernism: American Studio Jewelry 1940–1960.* Paris and New York: Montreal Museum of Decorative Arts in association with Flammarion, 1996.

Henshaw, Julia. *The W. Hawkins Ferry Collection.* Detroit: Detroit Institute of Arts, 1987.

In Nature's Embrace: The World of Harry Bertoia. Reading, PA: Reading Public Museum, 2006.

Kelly, Caleb. *Sound.* Cambridge, MA, and London: The MIT Press, 2011.

Larrabee, Eric and Massimo Vignelli. *Knoll Design.* New York: Harry N. Abrams, 1981.

Licht, Alan. *Sound Art: Beyond Music, Between Categories.* New York: Rizzoli, 2007.

Lutz, Brian. *Knoll: A Modernist Universe.* New York: Rizzoli, 2010.

Moore, Ethel. *Letters from 31 Artists to the Albright-Knox Art Gallery.* Buffalo: Buffalo Fine Arts Academy, 1970.

Nelson, June Kompass. *Harry Bertoia: Sculptor.* Detroit: Wayne State University Press, 1970.

Nelson, June Kompass. *Harry Bertoia, Printmaker: Monotypes and Other Monographics.* Detroit: Wayne State University Press, 1988.

Rapaport, Brooke Kamin and Kevin L. Stayton. *Vital Forms: American Art and Design in the Atomic Age, 1940–1950.* New York: Brooklyn Museum of Art in association with Harry N. Abrams, 2001.

Redstone, Louis G. *Art in Architecture.* New York: McGraw-Hill, 1968.

Schiffer, Nancy N. *Harry Bertoia: Monoprints.* Atglen, PA: Schiffer Publishing, 2011.

Selim, Shelley. *Bent, Cast & Forged: The Jewelry of Harry Bertoia.* Bloomfield Hills, MI: Cranbrook Art Museum, 2015.

Sculpture: Open-Air Exhibition of Contemporary British and American Works. London: London County Council, 1963.

Skarsgard, Susan. *Where Today Meets Tomorrow: Eero Saarinen and the General Motors Technical Center.* New York: Princeton Architectural Press, 2019.

Twitchell, Beverly H. *Harry Bertoia: An Exhibition of His Sculpture and Graphics.* Allentown, PA: Allentown Art Museum, 1975.

Twitchell, Beverly H. *Bertoia: The Metalworker.* London: Phaidon, 2019.

Vail, Karole. *The Museum of Non-Objective Painting: Hilla Rebay and the Origins of the Solomon R. Guggenheim Museum.* New York: Guggenheim Museum Publications, 2009.

Visions of Man in Ten Aluminum Sculptures. Richmond, VA: Reynolds Metal Company, 1966.

Webb, Aileen O. *Craftsmanship in a Changing World.* New York: Museum of Contemporary Crafts, 1956.

Articles, essays, and interviews

"The American Institute of Architects Awards Harry Bertoia the Craftsmanship Medal." *American Institute of Architects Journal* 25 (May 1956): 213.

"American Sculpture in Paris." *Art in America* 48 (Fall 1960): 96.

Andersen, John. "Design for Living." *Playboy* 8, no. 7 (July 1961): 108–10.

Belluschi, Pietro et al. "Views on Art and Architecture: A Conversation." *Daedalus* 89, no. 1 (Winter 1960): 62–73.

"Bertoia Mural Returned to New Dallas Library after Dispute." *Architectural Forum* 103 (November 1955): 29.

Bertoia, Harry. "Drawing Is a Way of Learning." *Arts & Architecture* 61, no. 4 (April 1944): 22–24.

Bertoia, Harry. "Five Drawings." *Arts & Architecture* 62, no. 5 (May 1945): 22–23.

Bertoia, Harry. "On Light and Structure (reprint of speech, International Design Conference, Aspen, CO)." *Print* 9, no. 6 (July–August 1955): 16–17.

Borsick, Helen. "Erieview Sculpture is an Eye-Catcher." *Plain Dealer* (Cleveland), February 17, 1966.

Breuning, Margaret. "Presenting Artists of the Inward Realm." *Art Digest* (July 1, 1946): 20.

Burchard, John E. "Alienated Affections in the Arts." *Daedalus* 89, no. 1 (Winter 1960): 52.

Chermayeff, Serge. "Painting Toward Architecture." *Arts & Architecture* 65, no. 6 (June 1948): 31.

Clute, Eugene. "Abstractions in Metal." *Progressive Architecture* 36, no. 2 (February 1955): 104.

"The Creation of an Unusual Metal Sculpture." *Minneapolis Tribune*, Sunday Picture Magazine, January 10, 1965: 4–5.

Creighton, Thomas H. "The Relationship of Sculpture and Architecture." *Progressive Architecture* 42, no. 11 (November 1961): 232.

"Dandelion Fountain Sculpture for Perpetual Savings and Loan Association, Beverly Hills, California." *Architectural Record* 133, no. 4 (April 1963): 310.

Frank, Peter. "Soundings at SUNY." *Art Journal* 42, no. 1 (Spring 1982): 58–62.

Frankenstein, Alfred. "Tobey and Bertoia: Fantasy and Geometry." *Art News* 44, no. 12 (October 1945): 28.

Guelft, Olga. "Bertoia: His Sculpture, His Kind of Wire Chair." *Interiors* 112, no. 3 (October 1952): 118–20.

Hakanson, Joy. "Sculptor Back at Cranbrook to Describe His Latest Work." *Detroit News*, November 20, 1962.

Hamilton, Chloe and Forbes Whiteside. "Sculpture 1950–1958: An Exhibition, February 14-March 17." *Allen Memorial Art Museum Bulletin* 15, no. 2 (Winter 1958): 59–85.

Holland, Frank. "Bertoia Sculpture Is Dazzling." *Sun-Times* (Chicago), December 16, 1956.

Huxtable, Ada Louise. "Art in Architecture 1959." *Craft Horizons* 19, no. 1 (January 1959): 12.

Huxtable, Ada Louise. "Banker's Showcase." *Arts 29* (December 1, 1954): 13.

"Interview with Harry Bertoia." *Interiors* 125, no. 4 (November 1965): 152–54.

"Knoll Associates Move into the Big Time." *Interiors 110*, no. 10 (May 1951): 74–83.
"The Knoll Interior." *Architectural Forum* 106, no. 3 (March 1957): 137–40.

Krasne, Belle. "Three Who Carry the Acetylene Torch of Modernism." *Art Digest 25*, no. 14 (April 15, 1951): 15.

Langsner, Jules. "Harry Bertoia." *Arts & Architecture* 70, no. 1 (January 1953): 12–15.

Loving, W. Rush Jr. "Sculptor Speaks: Changing Art Style Cited." *Richmond Times-Dispatch*, October 16, 1961.

"Metal Sculpture: Screen for the Manufacturers Trust Company." *Arts & Architecture* 72, no. 1 (January 1955): 18–19.

Montgomery, Susan J. "The Sound and the Surface: The Metalwork of Harry Bertoia." *Metalsmith* (Summer 1987): 22–29.

M. R., "Non-Objective Museum Holds Loan Show." *Art Digest* (November 1, 1943).

Mumford, Lewis. "Crystal Lantern." *New Yorker* 30 (November 13, 1954): 197–204.

O'Brien, George. "Art and Furniture Share a Showing." *New York Times*, December 13, 1963.

Oral history interview with Harry Bertoia, June 20, 1972. Archives of American Art, Smithsonian Institution.

"The Passing Shows." *Art News* 42, no. 13 (November 15–30, 1943): 23.

Pickens, Buford L. "Proud Architecture and the Spirit of St. Louis." *Architectural Record* 119, no. 4 (April 1956): 196–202, 278.

"Pure Design Research." *Architectural Forum* 97, no. 3 (September 1952): 142–47.

"Recent Sculpture U.S.A." *Bulletin of Museum of Modern Art* 26, no. 3 (Spring 1959): n.p.

"Reviews and Previews." *Art News* 45, no. 5 (July 1946): 44, 46.

Saarinen, Aline B. "Art as Architectural Decoration." *Architectural Forum* 100, no. 6 (June 1954): 132–35.

Sullivan, Marin R. "Alloyed Screens: Harry Bertoia and the Manufacturers Hanover Trust Building – 510 Fifth Avenue." *Sculpture Journal* 25, no. 3 (2016): 361–80.

Sullivan, Marin R. "Sculpture and Sound in the Windy City: Harry Bertoia's Standard Oil Commission." *Public Art Dialogue* 9, no. 1 (2019): 31–52.

Copyright and Photography Credits

Imprint

This volume is published in conjunction with the exhibition

Harry Bertoia: Sculpting Mid-Century Modern Life
Organized by and presented at the Nasher Sculpture Center, Dallas
January 29 – April 23, 2022

Harry Bertoia: Sculpting Mid-Century Modern Life is made possible by leading support from the Texas Commission on the Arts and Nancy A. Nasher and David J. Haemisegger. Generous support is provided in part by the National Endowment for the Arts and Dallas Tourism Public Improvement District (DTPID). Additional support is provided by Humanities Texas.

Concept: Jed Morse and Marin R. Sullivan
Copy editing and Proofreading: Emanuela di Lallo
Design: Sabine Hahn, Berlin, sh-gd.de
Pre-press, printing, and binding: O.G.M. SpA, Padua

© 2022 Nasher Sculpture Center, Dallas, and Verlag Scheidegger & Spiess AG, Zürich

© for the texts: the authors
© for the images: see Copyrights, pp. 222–223
© 2022 Estate of Harry Bertoia / Artists Rights Society (ARS), New York, for all works of art by Harry Bertoia

Verlag Scheidegger & Spiess
Niederdorfstrasse 54
8001 Zürich
Switzerland
www.scheidegger-spiess.ch

Scheidegger & Spiess is being supported by the Federal Office of Culture with a general subsidy for the years 2021–2024.

ISBN 978-3-85881-862-1